IMAGES
of America

THE LEHIGH VALLEY CEMENT INDUSTRY

Brennetta – Enjoy.

Joan

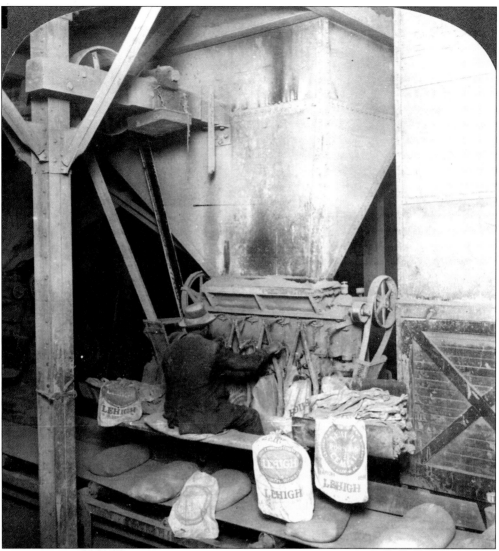

BAGGING, LEHIGH PORTLAND CEMENT, C. 1900. A bagger fills cloth bags with 94 pounds (one cubic foot) of cement in this stereoscope picture. Filled bags were carried away on the conveyer belt in the foreground. (Lehigh County Historical Society.)

IMAGES
of America

THE LEHIGH VALLEY
CEMENT INDUSTRY

Carol M. Front, Joan Minton Christopher,
and Martha Capwell Fox

ARCADIA
PUBLISHING

Published by Arcadia Publishing
Charleston, South Carolina

Printed in the United States of America

Library of Congress Catalog Card Number: 2005925672

For all general information contact Arcadia Publishing at:
Telephone 843-853-2070
Fax 843-853-0044
E-mail sales@arcadiapublishing.com
For customer service and orders:
Toll-Free 1-888-313-2665

Visit us on the Internet at www.arcadiapublishing.com

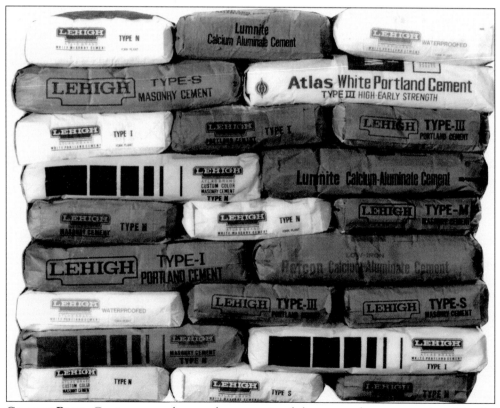

CEMENT BAGS. Contemporary bags make a mosaic of the types of cement produced by the Lehigh Cement Company. (Lehigh Cement Company.)

CONTENTS

Acknowledgments 6

Introduction 7

1. Cement's Foundations 9

2. Quarries 15

3. Pushing a Mountain through a Sieve 29

4. Making and Moving Cement 55

5. Liquid Stone 81

6. Workers and Their Families 89

7. Cement Today 123

ACKNOWLEDGMENTS

The authors wish to thank the people who added their expertise to this book. It was our privilege to be welcomed by individuals and companies who generously offered to share their photographs, knowledge, memories, and time. We encountered great enthusiasm for our project wherever we went.

We could not have done this book without Lance Metz and Tom Smith of the National Canal Museum. Lance was always available to answer our questions and introduce us to helpful contacts. Both Lance and Tom were very generous in allowing us the use of collection images. David Drinkhouse shared his vast knowledge of the cement industry and was gracious enough to read through our draft before it was finalized.

So many individuals were willing to help. Ron Wynkoop and John Metroke shared many photographs from Edison Cement as well as their expertise. Joe Yurko loaned photographs on the related railroads. Tom Biery shared a special photograph of his grandfather in the quarry as well as cement-related railroad photographs. Tom also read through our first draft. Frank Whelan informed us about the blast at Lehigh Portland, Sandt's Eddy. Ray Ziegler, Roy Lehr, and Henry Rockel met with us and loaned us photographs from Lehigh Portland in Fogelsville. Ilhan Citak and Eleanor Nothelfer from Lehigh University provided photographs from the Lehigh archive. Dick Schwechten's collection is well represented in this book.

We found that the retirees of the plants here in the valley were a marvelous source of information and a great group of folks. Both the Lehigh Portland and Keystone retirees groups invited us to their meetings. Kathleen Unger lent her photographs of Penn-Dixie.

A number of museums and historical societies came forward to add their collections and expertise. Carol Herrity of the Lehigh Valley Heritage Society was a great help. The Mack Truck Museum gave us cement truck photographs. Bill Burns at the Portland Cement Association answered our questions. Marjorie Rehrig at Bath Museum loaned us many views. Ed Pany gave us access to the Atlas Museum in Northampton. We were fortunate to be able to use photographs from Hunter-Martin Settlement Museum. The Northampton Historical Society allowed us to look over their collection.

Further help came from David Fronheiser at Bradley Pulverizing, who lent wonderful photographs. Ronald Golley of FL Smidth gave us access to the Traylor/Fuller/Smidth archive. The *Home News* in Bath printed two articles about our project and helped with scanning.

This book could have never come to be without the cooperation of the local cement companies that are still operating here in the valley. Our special thanks go to Corliss Bachman at Lehigh; Jeff Kaboly and Stephen Hayden Jr. of Keystone Cement; Vince Martin at Lafarge; Joe Pospisil of Hercules; and Marco Barbesta of Essroc.

There were so many people who helped us. Photographs and memories came from Susan Kirk, Ethel Kovach Nemith, Jane Spangler, Catherine Hahn, Pris Koch, Helen Farkas Siekonic, Anna Kish, Frank Yandrisevits, Kathy Sakasitz, Roy Bottjer , and Nancy Merke. Thank you all for your help.

Finally, thank you to our friends and families.

INTRODUCTION

The portland cement industry in the United States began in the Lehigh Valley, partly because of its geology. The Jacksonburg Formation, a narrow but deep band of limestone, arcs just below the surface of the ground from eastern Berks County, Pennsylvania, through upper Lehigh and Northampton Counties to western Warren County, New Jersey. The formation's rocks yield up the world's most nearly perfect mix of ingredients for portland cement—a blend of high-quality limestone that is almost pure carbonate of lime, as well as clay-based argillaceous, or bastard, limestone. This combination, heated nearly to the point that it turns to glass, becomes portland cement.

Cement is the second most used resource in the world, after water. Humanity has known for thousands of years that certain types of rock make good binding material, once they are ground up, burned, and mixed with water. The Romans discovered that a mixture of lime and volcanic ash not only made a hard, reliable mortar, but it hardened under water. Roman hydraulic cement, called *pozzolana*, was used for centuries and, even after 2,000 years, still holds together structures such as the Coliseum and the Pantheon.

The Romans' knowledge was lost until 1756, when John Smeaton, a British engineer, rediscovered hydraulic cement. Smeaton had been commissioned to rebuild a lighthouse on the English Channel and was faced with the challenge of building a brick tower on partially submerged rocks. He found that clayey limestones burned at a certain temperature and slaked (mixed with water) produced cement that not only would set underwater but was strong enough to withstand the forces of winds and tides. Then Smeaton discovered that a supply of volcanic ash had been imported from Italy, and when he mixed that with his limestone and burned the mix, he got cement that was not only hydraulic and strong but quick-setting. Smeaton used his new cement to construct the Eddystone Lighthouse, which withstood 123 years of waves and weather before being torn down for a larger light. This was the first modern use of natural cement.

Nearly 70 years later, in 1824, Joseph Aspdin, a mason and bricklayer in Leeds, made a mix of limestone and clay, ground it very fine, mixed it with water and then allowed it to dry. Then he ground it up again, burned it in a lime kiln to drive off all the carbonic acid in the stone and ground it a final time. Aspdin called the resulting powder "portland" cement, because when it was applied as stucco to a building, it resembled the highly desirable stone from the Portland quarries on the south coast of England.

Stronger and far more durable than natural cement, portland cement quickly became the building material of choice for the madly expansive 19th century. Railroads, huge factories, massive docks, large public works, roads, bridges, and ever higher office buildings demanded the best cement. European portland cement came to dominate not only the construction projects of the Old World but those of America as well.

When the Lehigh Valley Railroad pushed up the west bank of the Lehigh River in the 1850s, it exposed a long wall of rock just north of a tiny settlement called Schreiber's. Shortly after the Civil War, three Allentown businessmen—David Saylor, Esias Rehrig, and David Woolever—realized that this was yet another deposit of the stone that had been used to make natural cement in the area for nearly 40 years. They began the Coplay Cement Company in 1866 and started producing a couple hundred tons of natural cement a week from two kilns. Saylor, however, thought they could do better.

Experimenting on his cement rock in his kitchen, using nothing more than the family cook stove and a coffee grinder, Saylor persisted through a hit-and-miss process until he found the

temperature-and-limestone combination that produced portland cement equal to the kind that was being imported from Europe. He patented it in 1871 and then set out to convince American builders that his portland cement was as good, and as cost-effective, as European.

Saylor's Coplay Cement and the entire domestic industry got a major boost when the Eads Jetties in New Orleans, the first major Army Corps of Engineers public works project, used only Saylor cement in 1878. Although the industry began to grow and plants were established in New York, Indiana, Texas, Oregon, and Michigan, portland cement manufacture did not really take off until the introduction of the rotary kiln by Jose de Navarro in 1886. In 1880, the total U.S. production of portland cement was 42,000 barrels, most of it produced in the Lehigh Valley. In 1890, there were 335,000 barrels produced, but in 1900, the total stood at nearly 8.5 million, more than the annual average production of 8 million barrels of natural cement. Natural cement declined rapidly thereafter and virtually disappeared after about 1920.

Cement mills in the Lehigh District produced 70 percent of those 8.5 million barrels in 1900. By 1910, quarries and plants dotted the landscape in an arc that ran from New Village in Warren County, New Jersey, across the Delaware to Martins Creek, through Stockertown, Nazareth, Bath, Northampton, Cementon, Egypt, Ormrod, and Fogelsville to Evansville, Pennsylvania. The industry spread rapidly around the United States as the demand for cement rose and more places were found with good-quality stone, although never with quite the same composition as the Jacksonburg rock.

The cement industry closely mirrors the economy. The years following World War II were a boom time, especially because of the construction of the Interstate Highway System. On the other hand, the Great Depression, and the recessions of the 1970s and early 1980s, forced many companies to either close or consolidate. The remaining plants soon acquired European partners or outright owners; today, foreign companies own about 70 percent of American cement production. In 2005, all five of the companies operating in the Lehigh District are foreign-owned and running at peak output to meet the soaring worldwide demand for cement.

This book is far from a comprehensive history of the cement industry in the Lehigh Valley. It is, however, the result of the enthusiasm, advice, cooperation, and generosity of many people, some of them working in the cement industry and others who are retired or are the descendants of early valley cement workers. Companies, museums, and individuals all opened their photograph collections, and the result of their goodwill is this photographic look back at the industry that helped shape the Lehigh Valley and the nation.

One

CEMENT'S FOUNDATIONS

The construction of the Lehigh Coal and Navigation Company's canal from Easton to Mauch Chunk (now Jim Thorpe) in the 1820s triggered the first cement making in the Lehigh Valley. Rock suitable for making the hydraulic cement needed for locks and overflows was found near Lehigh Gap and at Siegfried's Bridge (now Northampton). Samuel Glace, supervisor of the stretch of the canal from Slate Dam to Allentown, operated a cement mill at Lehigh Gap until the canal was completed in 1830.

That year, four kilns were erected at Siegfried's, where 10 barrels of natural hydraulic cement were made a day. This cement was kept on hand to repair breaches (often made by muskrats) in the banks of the canal. Holes had to be fixed quickly, or an entire stretch of the canal would soon be waterless. The repair boat would make its way to the break, with all canal traffic yielding the right of way, while Glace and his crew on board made concrete with the cement, gravel, and sand and mixed it with water from the canal. When the boat arrived at the leak, a coffer dam was erected, the water emptied from the area, and the concrete applied to the hole. When the cement was set, the boards and coffer were removed and normal traffic resumed until the next muskrat struck.

At least three companies made natural cement along the banks of the Hokendauqua Creek before 1875. Even after Saylor began making portland cement in Coplay, many people believed that the rock east of the Lehigh River was suitable only for natural cement. This quickly proved untrue, and soon the name Lehigh became synonymous with cement.

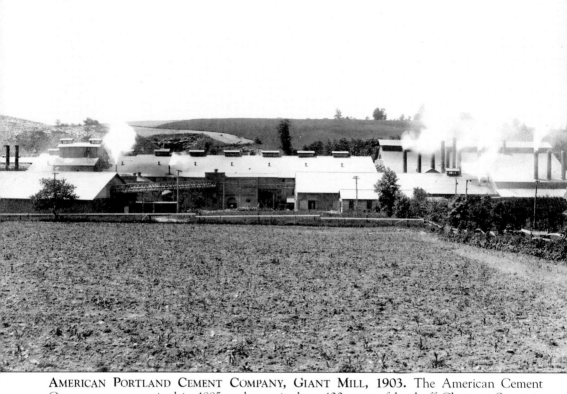

AMERICAN PORTLAND CEMENT COMPANY, GIANT MILL, 1903. The American Cement Company was organized in 1885 and was sited on 400 acres of land off Chestnut Street in Egypt. The Giant Mill, one of four the company operated, produced both natural and portland cement. The building on the right, with the smokestacks, contained four rotary kilns for making portland cement, while 18 shaft kilns, under the long roof in the center of the photograph, produced natural cement. (Lehigh County Historical Society.)

DAVID O. SAYLOR. The father of the American portland cement industry, David O. Saylor (1827–1884), began his career in his father's grocery businesses in Butztown and Shoenersville, but by his late 30s, he was still not much of a success. Esias Rehrig and David Woolever, both prominent in Allentown politics and business, encouraged him to get into the natural cement business, and the three founded the Coplay Cement Company in 1866. Buoyed by his first real achievement, Saylor's genius and perseverance came to the fore. In 1871, he won the first American patent for portland cement and set out selling it to the nation. In the remaining 13 years of his life, he was active in the Allentown Board of Trade and was instrumental in bringing the silk industry and many other new businesses to the Lehigh Valley. (Lehigh County Historical Society.)

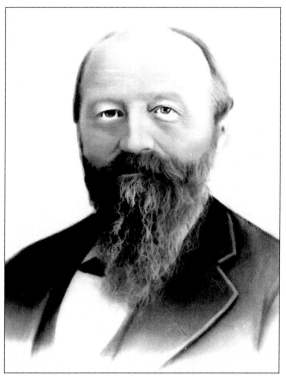

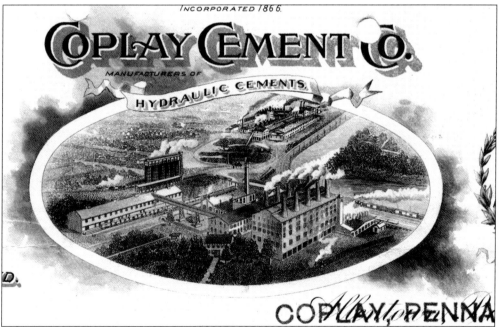

COPLAY CEMENT COMPANY, 1900. This steel engraving, from a letterhead, depicts Mill B, with the 10 vertical continuous-firing Schoefer kilns in the foreground, and Mill A in the rear. At the bottom center of the image is the 1799 Schreiber homestead, the first house in Coplay, which was used as offices for the cement company and later as a tool and machine shop. (National Canal Museum.)

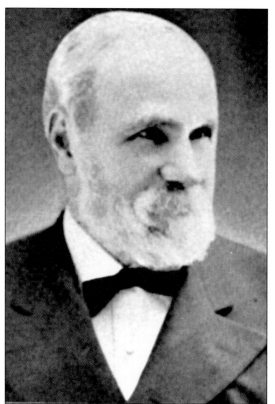

JOSE DE NAVARRO. Spanish-born Jose de Navarro (1823–1909) epitomized the 19th-century entrepreneur. During his 70-year career, de Navarro started eight major companies, including the Ingersoll Rock Drill Company and New York City's Metropolitan Elevated Railway. He built the immense Spanish Flats apartments on Central Park South. In 1886, he installed a rotary kiln at Union Cement Company in Rondout, New York, the first one used in an American cement plant. Three years later, he opened Keystone Cement in Coplay; he installed the Lehigh District's first rotary kiln there. Still at work in his 80s, de Navarro moved his company, now called Atlas Cement, to Northampton in 1905. (National Canal Museum.)

ATLAS CEMENT PLANT NO. 3, C. 1915. This is one of three plants (the others were No. 2 and No. 4) at the site on the east side of Northampton that made up the largest cement mill complex in the world in the 1930s. Jose de Navarro built the No. 2 plant on the site in 1895 and moved most of the Atlas Cement's operations to Northampton 10 years later. The company became Universal Atlas Cement in 1930, following a merger with Universal Cement and purchase by U.S. Steel. The company operated in Northampton until 1982. (National Canal Museum.)

FRED B. FRANKS. The Lehigh District's prodigious builder of cement mills, Fred B. Franks (1870–1969), started out in house construction in Philadelphia. In the early 20th century, he built the William Krause and Sons Cement Company near Martins Creek (later Alpha Portland) and the Bath Portland Cement Company. In 1926, he built the Sandt's Eddy plant, which he later sold to Lehigh Portland, and in 1927 founded Keystone Portland in Bath (the nearby intersection of Airport Road and the Nor-Bath Pike is still known as Franks Corners). In 1931, he founded the National Portland Cement Company on Hanoverville Road (its quarry is now Dutch Springs dive center), and in 1934, he took over Allentown's Horlacher Brewery and remained active as its vice president until three years before his death.

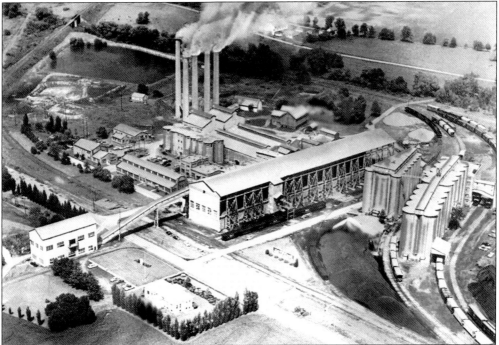

KEYSTONE PORTLAND CEMENT COMPANY. Keystone Portland Cement Company began production in 1928 using a "wet" process devised by Fred Franks. Franks's process is still in use, as is some of the original grinding equipment, although the kilns and other facilities were modernized in the 1960s. Keystone's 780-acre quarry contains the largest stone reserves in the Lehigh District.

GEN. HARRY C. TREXLER. Harry Clay Trexler (1854–1933) was the most energetic and visionary businessmen in Lehigh Valley history. In his 30s, he built the family lumber business into one of the largest in the United States and at 40 was Pennsylvania's leading farmer, growing fruit, grain, potatoes, and poultry on 25,000 acres. General Trexler (he held the rank of brigadier in the Pennsylvania National Guard) served on the Allentown Board of Trade and donated time, money, and energy to the city's schools, civic life, and recreation facilities. In 1897, he organized Lehigh Portland Cement with Edward Young and George Ormrod, remaining active in the company until his death. With Young, he created Lehigh Valley Transit, which built Lehigh Portland's cement showcase, the monumental Eighth Street Bridge. Trexler consolidated several small electric companies into Pennsylvania Power and Light (now PPL) and did the same with local telephone companies, which he unified and sold to Bell Telephone of Pennsylvania. The land Trexler bequeathed to Allentown and Lehigh County makes up an extensive public park system and the Lehigh Game Preserve. (Lehigh Cement Company.)

Two

QUARRIES

Vast, deep quarries pit the Jacksonburg Formation. Some are abandoned, but many have been worked for half a century or more. In 1916, the Saylor Portland Cement Company's 50th anniversary book called its quarries, purchased by David Saylor himself, "practically inexhaustible." In the early 1940s, Lehigh Portland president Joseph Young wrote that the average cement plant chewed up four acres of stone, 50 feet thick, each year. Even at that rate, the rock will not run out anytime soon.

Originally, quarries were the most labor-intensive and dangerous parts of the cement operation. Gangs of men broke the blasted-out rock down to sizes small enough to be picked up and carried to a waiting mule-drawn cart. Carts were replaced with skip cars, shallow mine cars with flanged wheels that ran on temporary tracks thrown down to the latest rockfall. Thomas Edison is credited with putting steam shovels to work in quarries, scooping up tons of large rocks at a time and doing the work of dozens of men in just minutes.

From the quarry, rock was transported to the crusher a number of ways, including gravity railroads, inclined planes, being hauled by small engines, and beginning in the late 1930s, by dump trucks. Today, many mills transport stone by conveyor belts. Essroc's new 1.7-mile-long conveyor moves 1,200 tons of rock per hour. Modern equipment, including giant shovels and trucks, mean that even a handful of workers can move massive quantities of rock.

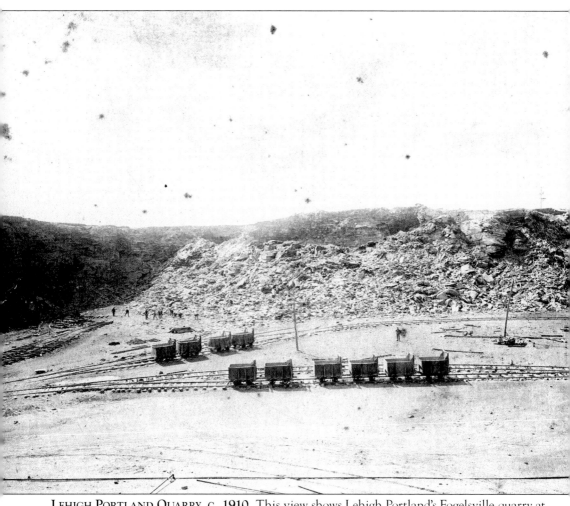

LEHIGH PORTLAND QUARRY, C. 1910. This view shows Lehigh Portland's Fogelsville quarry at

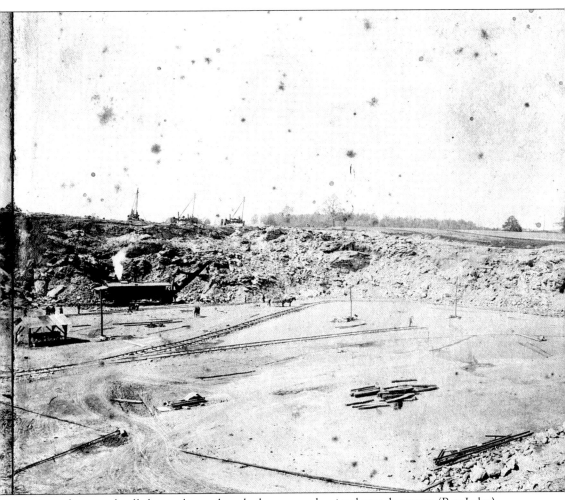

a time when nearly all the work was done by human and animal muscle power. (Roy Lehr.)

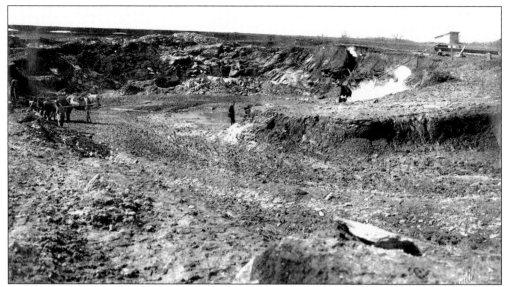

ALLENTOWN PORTLAND CEMENT COMPANY QUARRY, EVANSVILLE. This quarry, in northwestern Berks County, appears to have been recently opened in this photograph, dated March 17, 1909. It shows the preferred technique of cutting into a hillside to expose the cement rock. Note the men moving stone by hand and the horse-drawn cart. (Edward Pany.)

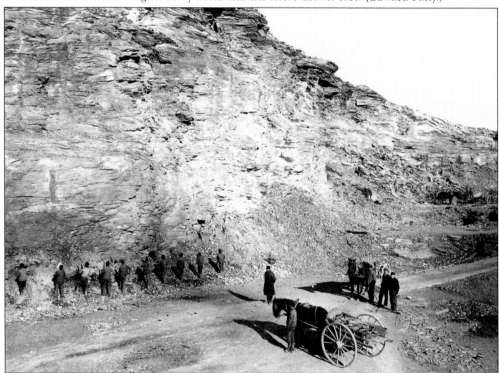

PENNSYLVANIA PORTLAND CEMENT COMPANY QUARRY. The Pennsylvania Portland Cement Company opened just east of Bath in 1903. The line of men is breaking up loosened rocks into pieces small enough to be carried to the waiting cart. This quarry was largely abandoned when the mill was taken over by the Penn-Dixie Company in 1926. (Lehigh County Historical Society.)

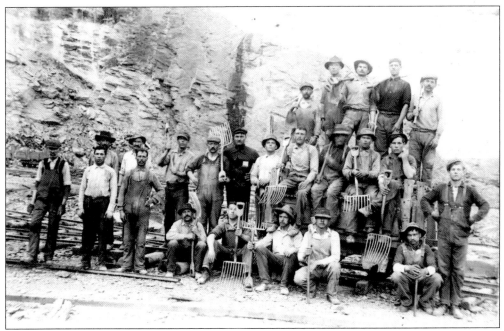

QUARRY NOS. 3 AND 2. By the time these photographs were taken, rock was being moved in small cars called skips, which were pulled over temporarily laid tracks on the floor of the quarry. After a blast loosened a quantity of stone, the tracks were laid right up to it, and the cars drawn up and filled. However, the rocks still had to be broken up by hand to a size a man could lift. Their tools, picks, and 10-tined stone forks can be clearly seen in the photograph above. The mills these quarries supplied are unknown. (Lehigh County Historical Society.)

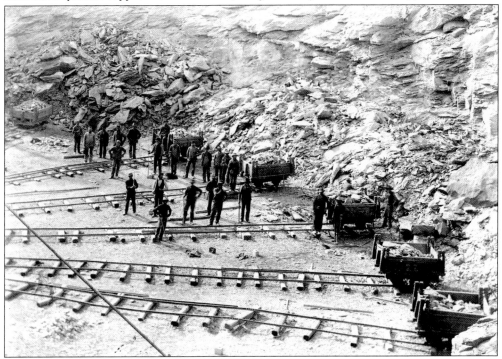

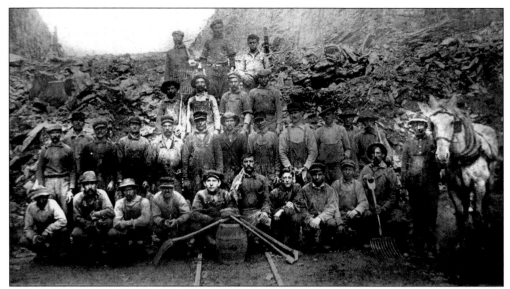

QUARRY NO. 2, LAWRENCE CEMENT COMPANY, 1910. Quarry workers in Northampton display the tools of their trade—sledge hammers, 10-tined stone forks, and a small barrel of blasting powder. The mule pulled small "skip" cars filled with rock over the rails that are visible in the bottom center of the picture. The only man whose identity is known is Andrew Kovach, ninth from the left in the second row. Like many of his coworkers, Kovach was a recent immigrant, arriving in Northampton in 1904 from Austria-Hungary. (Ethel Kovach Nemith.)

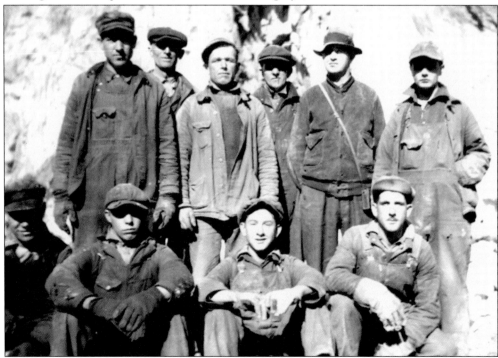

QUARRY WORKERS, ALPHA PORTLAND CEMENT COMPANY. Quarry workers pose for a picture in the pit near Martins Creek. Notice that their only protective gear is heavy gloves. (Ron Wynkoop Sr.)

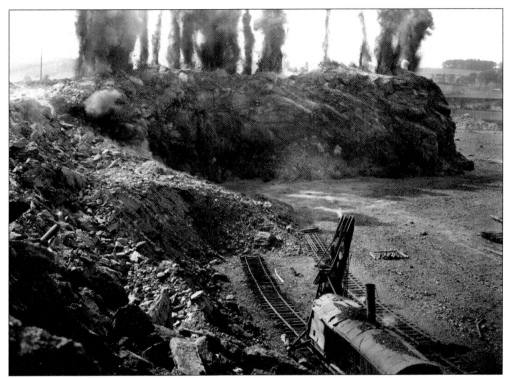

BLASTING, PHOENIX PORTLAND QUARRY. This unusual photograph shows the split second after the detonation that would reduce this wall of stone to a tumbled heap like the one on the left of the picture. Notice the loosely laid temporary tracks for the steam shovel and skips to reach the rock pile and the pile of ties to the right of the shovel. (Kathy Sakasitz.)

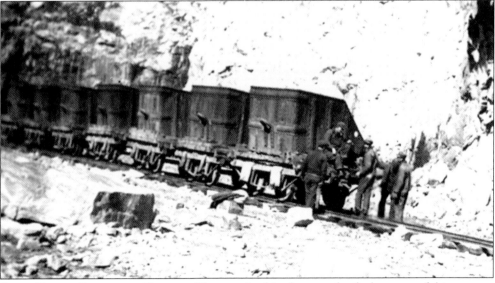

SKIPS, EDISON PORTLAND QUARRY. The men in this photograph of a long row of skips appear to be taking a break on the platform of the end car, but in some quarries the cars were pushed by hand to the crusher or the incline. The Easton Car and Construction Company manufactured skip cars and other railroad cars in South Easton. (John Metroke.)

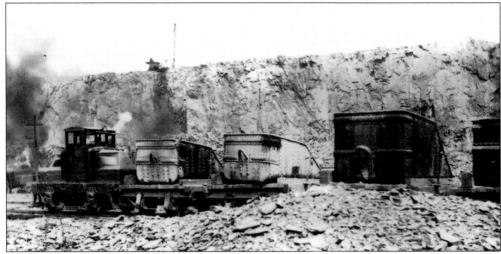

QUARRY LOCOMOTIVES. By the 1930s, mules had been replaced with small locomotives that pulled the skips out of the quarry, or at least as far as the incline. Two very different styles of locomotives are shown here in the Edison Portland Cement quarry (above) and the Whitehall Portland quarry (below). (Above, John Metroke; below, Dick Schwechten.)

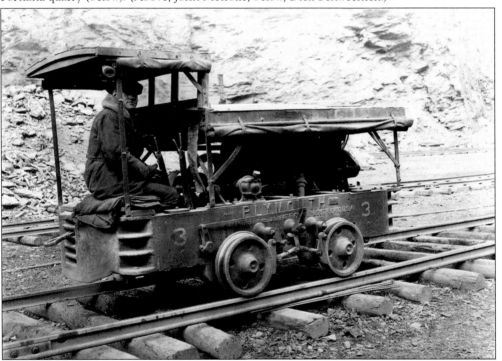

INCLINE, WHITEHALL PORTLAND CEMENT QUARRY. In quarries that were completely below the surface of the surrounding ground, stone was hauled to the top on inclined planes. The Whitehall quarry's incline, shown in the photograph on the right, boasted a "flying" switch, which could be used two ways; a full car could be pulled up while an empty one descended, or empty cars could be sent to two different locations on the bottom. Compare the temporary construction of these tracks with the permanent installation shown on page 25. (Dick Schwechten.)

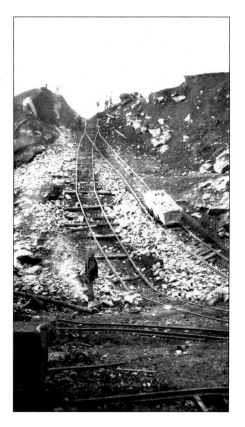

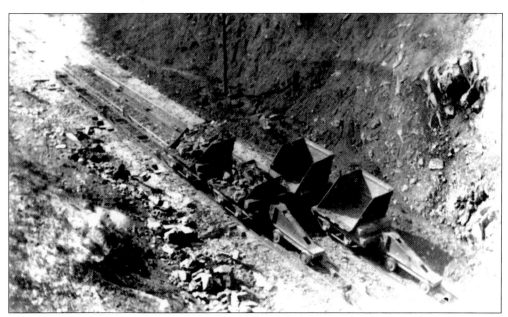

INCLINE, EDISON PORTLAND QUARRY. Fully loaded skip cars, heading up the incline, pass empty ones returning to the quarry for more stone. (John Metroke.)

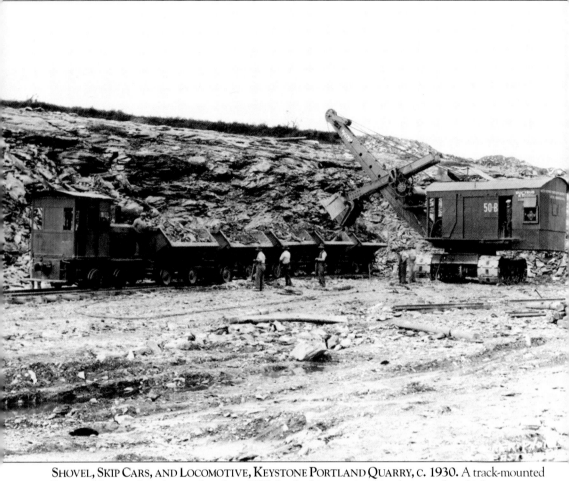

SHOVEL, SKIP CARS, AND LOCOMOTIVE, KEYSTONE PORTLAND QUARRY, C. 1930. A track-mounted Bucyrus electric shovel, introduced in 1925, loads skip cars in this photograph, which appears to have been taken not long after the quarry was opened. Note the rails and ties scattered on the ground in the foreground. (Bath Museum.)

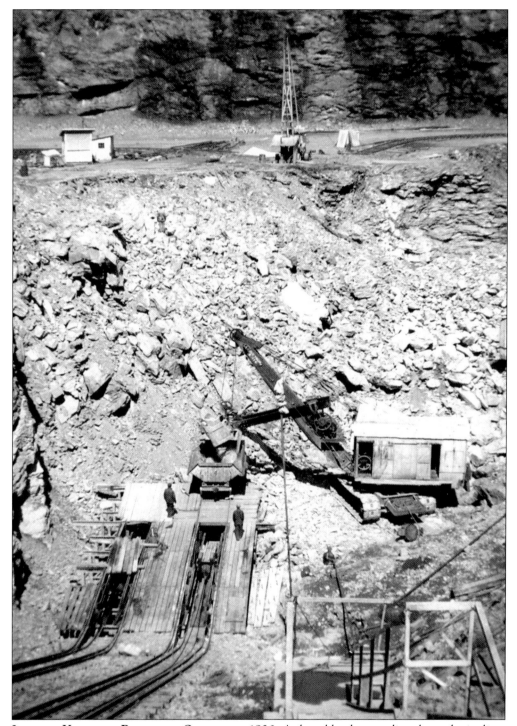

INCLINE, KEYSTONE PORTLAND QUARRY, C. 1930. A shovel loads a car directly on the incline. The steel structure in the background is a churn drill, used for driving holes in the rock where explosive charges were placed. (Keystone Cement Company.)

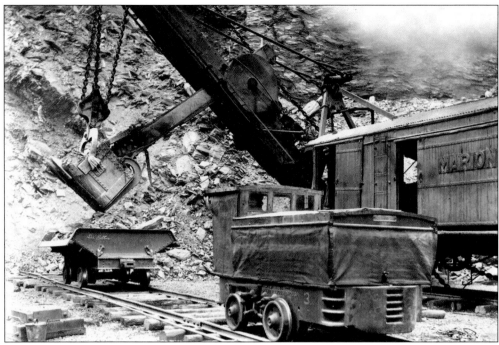

FROM TRACKS TO TRUCKS. A Marion steam shovel loads a shallow skip car in the Whitehall Portland quarry while a small locomotive waits to haul it away (above). By 1948, when the photograph below was taken in the Universal Atlas quarry in Northampton, heavy-duty trucks, like this 10-wheeler Mack, had replaced skip cars. (Above, Lafarge; below, Mack Truck History Museum.)

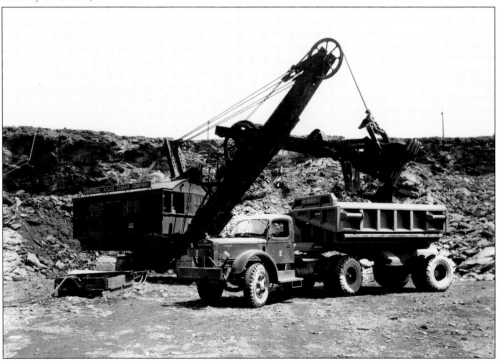

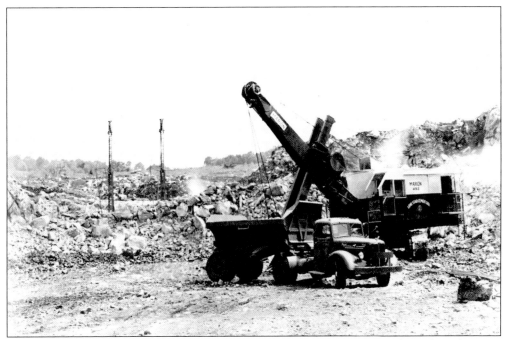

Truck Takeover. A Marion diesel-electric shovel loads stone onto a Mack truck in the Lone Star Cement quarry near Nazareth in July 1951 (above). Below, drivers pose with Universal Atlas's fleet of Mack quarry trucks in July 1948. The presence of the drivers gives a clue of the size of the trucks. (Mack Truck History Museum.)

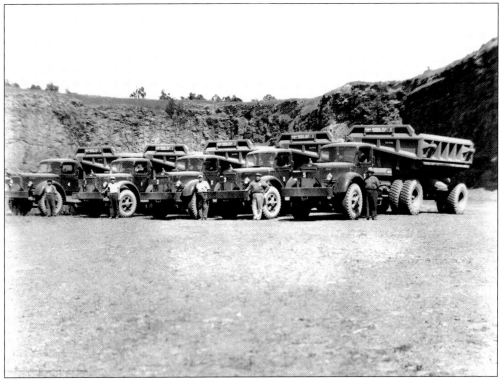

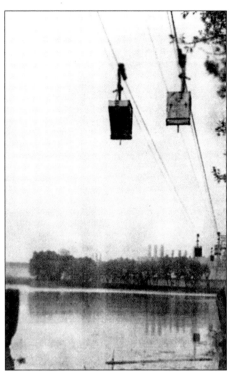

PENN-DIXIE ELEVATED BUCKETS AND QUARRY AT PLANT NO. 4, 1947. Penn-Dixie Cement transported stone via a two-and-a-half-mile-long aerial tram (left) from the quarry just west of Nazareth (below). The tram cars held .9 ton of rock and moved at a speed of 500 feet per minute. Cars driving beneath the tram on Route 248 east of Bath were often pelted by small rock blown from the aerial cars, but a wide, steel-mesh screen shielded the road where the tram reached Mill No. 6. (Bath Museum.)

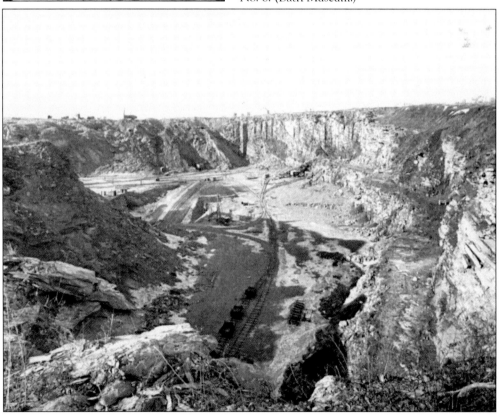

Three

PUSHING A MOUNTAIN THROUGH A SIEVE

Once the rock has left the quarry, it is destined for a series of crushings that will eventually reduce it to a powder so fine that it will pass through a sieve that holds water.

The process of making portland cement has been described a "pushing a mountain through a sieve." It has not changed greatly in the past century, although a host of refinements have made the industry much more efficient, productive, and safe. The rock is crushed to a size about six inches in diameter and then to pieces about two inches or smaller. These fragments may be mixed with additional limestone to reach the desired proportions of the minerals needed to make portland cement, then ground into a fine powder. The mix is fed into rotary kilns and burned at approximately 2,700 degrees Fahrenheit, which converts the rock mixture into "clinker" about the size of marbles. The clinker is cooled and then re-pulverized into cement, which is then stored or bagged for shipping.

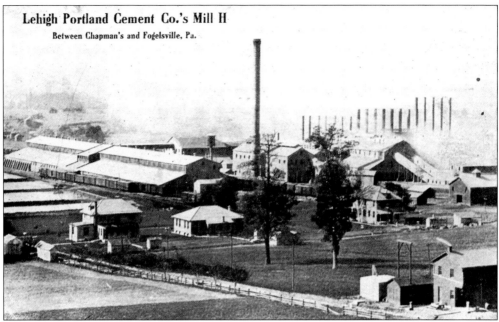

Lehigh Portland Cement Co.'s Mill H

Between Chapman's and Fogelsville, Pa.

LEHIGH PORTLAND CEMENT COMPANY, MILL H. Lehigh Portland began building the mill east of Fogelsville in 1905 on a tract of 1,300 acres. The plant, the company's fifth installation in only eight years of existence, covered 20 acres, while the quarry encompassed another 12 acres. Company houses and a boardinghouse were built, and the community became known as East Fogelsville. (Above, Ray Zeigler; below, Henry Rockel.)

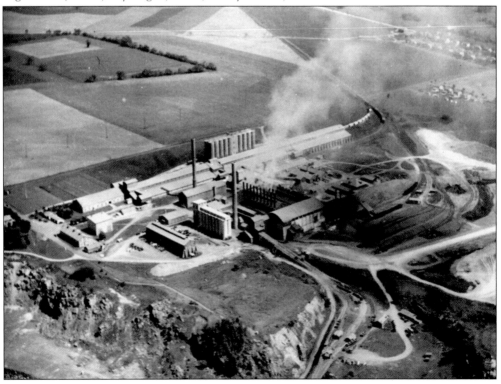

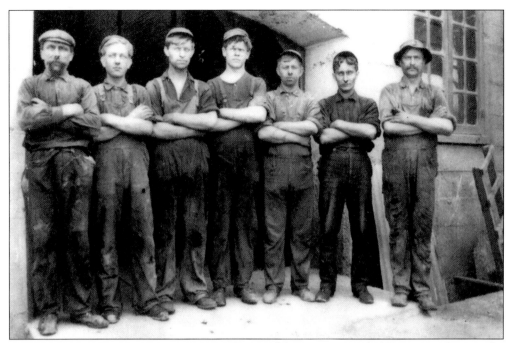

LEHIGH PORTLAND EMPLOYEES, C. 1910. Seven of the approximately 350 men working in the Fogelsville plant are seen here. Although none of their tools are evident, they may have been coopers, or barrel makers. (Lehigh Cement Company.)

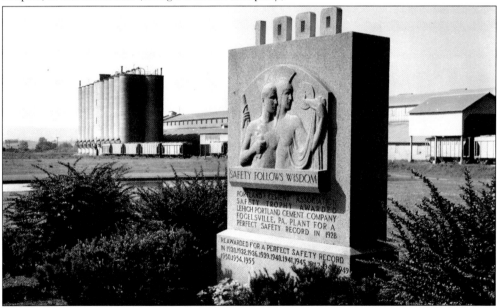

LEHIGH PORTLAND CEMENT, FOGELSVILLE. By the time this picture was taken around 1960, the company had dispersed its production and delivery facilities all over the United States. The coveted "1000" atop the Portland Cement Association Safety Trophy, first awarded to the mill in 1928, stands for 1,000 days of operation without a lost-time accident. The Fogelsville plant remained in operation until 1970. After shutting down, the plant was dismantled, and the site is now the Iron Run industrial park. (Lehigh Cement Company.)

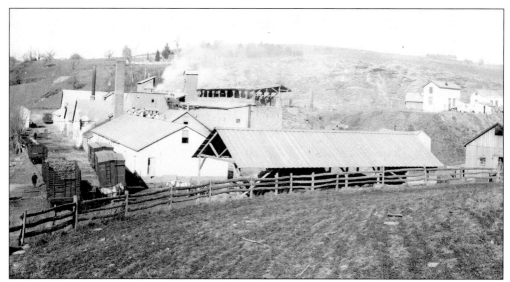

AMERICAN CEMENT, EGYPT WORKS, 1899. Organized in 1883 and originally known as the American Improved Cements Company, American Cement produced natural and portland cement. The company was founded by John Trinkle and Robert Lesley, who were importers of European portland cement. Lesley, nevertheless, thought the market for natural cement was stronger, and he walked the length of the Jacksonburg Formation, from Martins Creek westward, testing samples of rock. Much to his later regret, he rejected Northampton County's high lime-content stone that was soon bought up by portland cement makers like Alpha, Bath, and Dexter. He found the stone he was looking for in Egypt and built this first mill, where he installed the first Griffin Mill used in a cement plant. (Lehigh County Historical Society.)

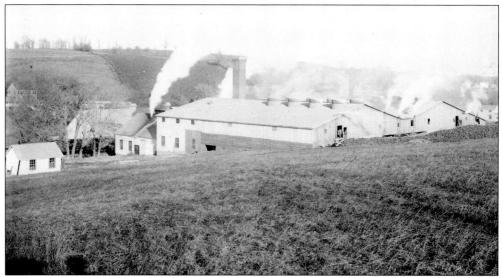

AMERICAN CEMENT, PENNSYLVANIA WORKS, 1899. This mill operated shaft kilns that produced natural cement; nevertheless, its founder, Robert Lesley, is credited with being one of the best salesmen the domestic portland cement industry had. Although he started his career as a clerk in the advertising department of a Philadelphia newspaper, Lesley gained membership in most of the leading engineering associations and tirelessly promoted portland cement, made by his own company as well as that of others such as David Saylor. (Lehigh County Historical Society.)

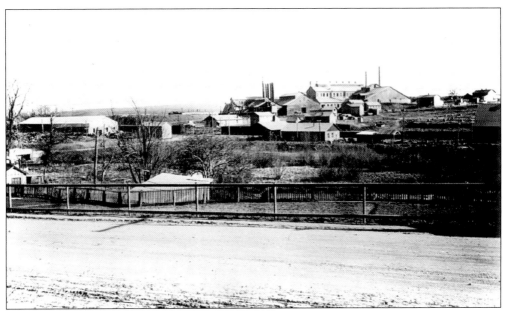

AMERICAN CEMENT, COLUMBIA AND CENTRAL MILLS. The Central mills were opened in 1903 and operated under the name Giant Portland Cement Company until 1975. This photograph is looking south from Chestnut Street; the area is now a Whitehall Township park. (Lehigh County Historical Society.)

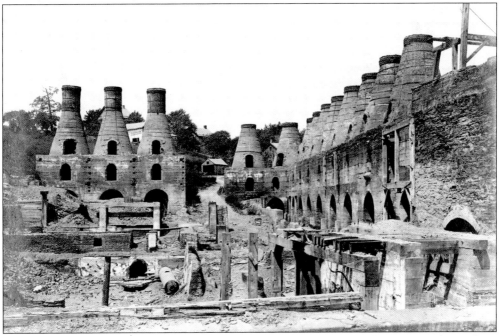

COPLAY CEMENT MILL A, 1922. These are the ruins of David Saylor's first cement plant, where he made both natural and portland cement starting in 1866. By 1891, there were 33 shaft kilns operating on this site, which stood about a quarter mile north of the Schoefer kilns that are all that remains of Mill B. The ruins were completely covered with stripping from the development of Plant C's quarry. (Lehigh County Historical Society.)

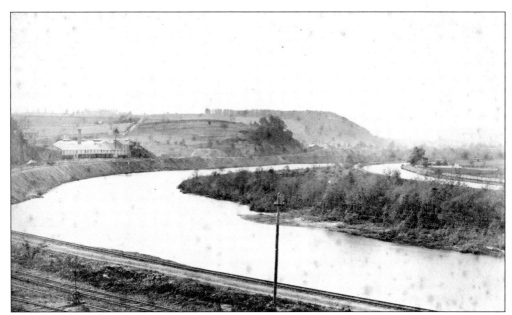

COPLAY CEMENT WORKS, OCTOBER 7, 1881. David Saylor's original cement plant is seen here. In 1884, Coplay Cement had 17 kilns, 13 making portland cement, and 4 turning out natural Anchor brand cement. The portland kilns were the intermittent, bottle-shaped type, designed by Englishman James Hubett; the natural cement was made in old-style draw kilns. This mill produced about 300 barrels of each kind of cement a day and employed about 150 men as coopers, mill hands, and quarrymen. (Lehigh County Historical Society.)

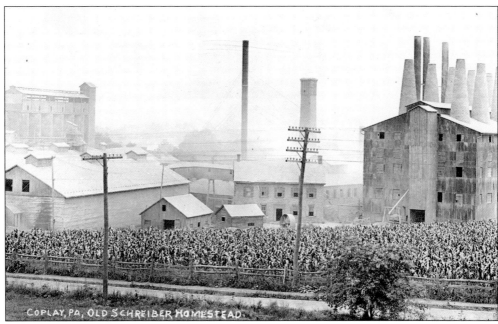

COPLAY CEMENT WORKS, PLANT B. The Schreiber homestead, the first house in the area that became Coplay, stands surrounded by the cement mills. The house, built in 1799, was used as company offices and later as a machine shop. (Lehigh County Historical Society.)

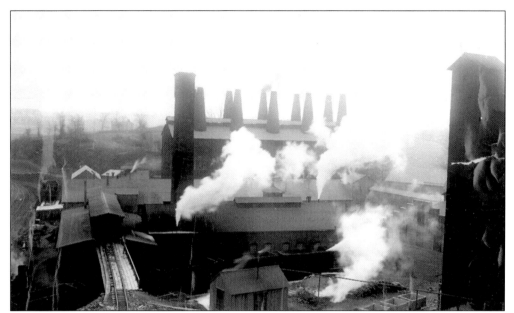

COPLAY CEMENT MILL B, C. 1900. Mill B was constructed just north of Coplay in 1892. The 10 kilns, whose tops are visible, were continuous-firing vertical kilns, or Schoefer kilns, a major breakthrough in portland cement technology. In little more than a decade, though, they were obsolete, replaced by bigger, more efficient horizontal rotary kilns. The mill was demolished for scrap in 1950. The kilns, with the upper 40 of their original 120 feet lopped off for safety reasons, were left standing. (Raymond E. Holland.)

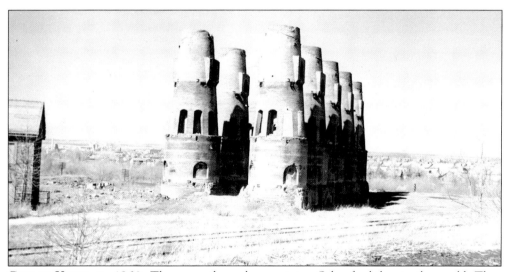

COPLAY KILNS, C. 1960. These are the only remaining Schoefer kilns in the world. They are still standing only because there were "certain mechanical problems" with tearing them down, general manager D. J. Uhle told the *Evening Chronicle* in 1951. The site became Lehigh County's Saylor Park in 1976, but through time and neglect, the kilns are again threatened with destruction. A local group, the Saylor Cement Kilns Preservation Society, is attempting to create a foundation to ensure the kilns' survival and preservation. Note the corner of the Schreiber homestead visible on the left. (Lehigh County Historical Society.)

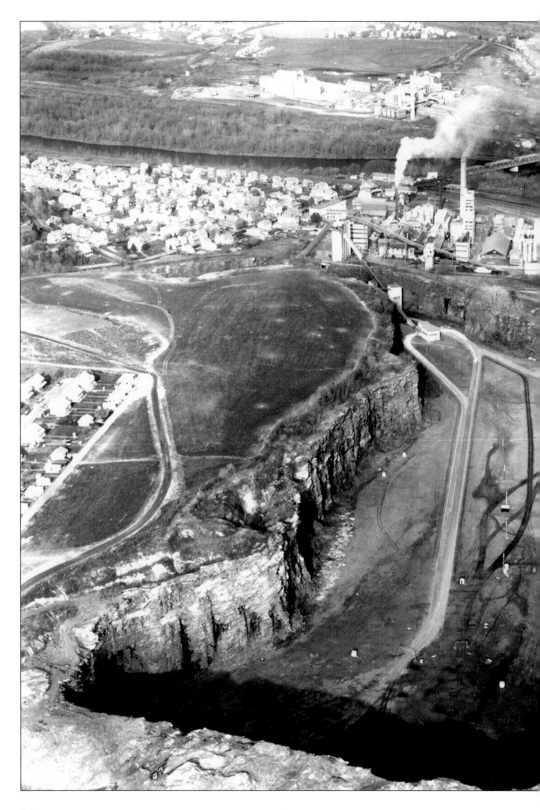

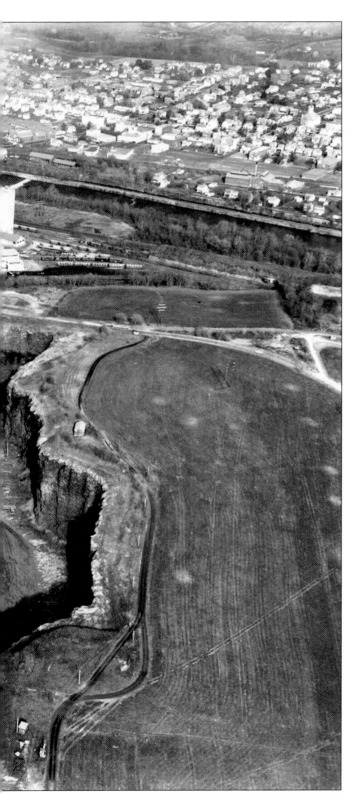

WHITEHALL CEMENT COMPANY, C. 1950S. When Whitehall Cement began in 1899, it was the largest single mill in the Lehigh District, with 20 rotary kilns. Company houses for workers in the neighborhood known as Dewey Heights are visible on the left side of the photograph. Although the houses are now privately owned, Lafarge Cement, the present operator of the plant, retains the rights to the land on which they stand. This allows for the eventuality of expanding the quarry. (Lafarge Cement.)

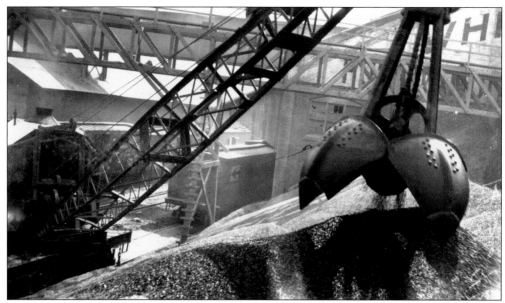

CRANE AND COAL, WHITEHALL CEMENT. For most of the 20th century, pulverized bituminous coal was the chief energy source used by cement plants. A Universal Atlas Company publication from the 1930s said that a cement plant "devoured coal" and that its "appetite for coal is never satisfied." Cement mills pulverized the coal to make it burn more efficiently. (Dick Schwechten.)

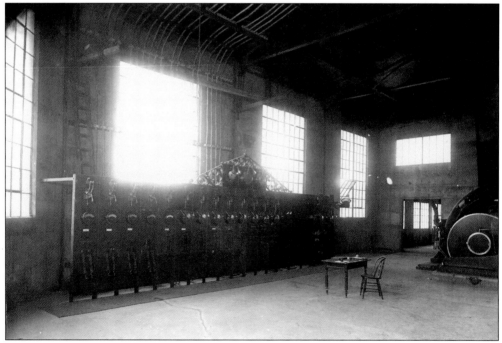

ELECTRICAL SWITCHING GEAR, WHITEHALL CEMENT, C. 1910. Whitehall Cement was the first plant in the Lehigh District to run largely on electricity. The plant generated its own power and supplied its surplus electricity, free, to the village of Cementon. Most cement plants made their own electricity by capturing waste heat from the kilns and using the heat to make steam to drive the turbines. (Dick Schwechten.)

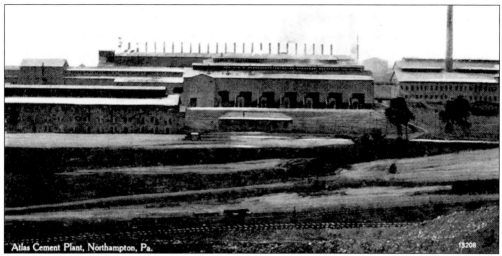

ATLAS CEMENT PLANT, NORTHAMPTON, C. 1920S. This postcard dates to the years before the Atlas and Universal Cement Companies merged and became a subsidiary of U.S. Steel in 1930. At its height, Universal Atlas operated around the clock and employed over 5,000 workers. The company's Northampton plant made a wide variety of cements; 4 of its 25 kilns were dedicated to producing a pure white portland used for house stucco and decorative purposes. (Dick Schwechten.)

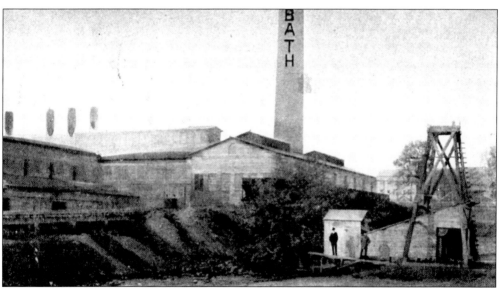

BATH PORTLAND CEMENT COMPANY, C. 1906. Fred B. Franks opened the Bath Portland Cement Works in 1905. The plant was located about a mile and a half southwest of Bath. The entry about the company's quarries in the 1938 *Geology of Northampton County* illustrates the uncertainties of quarrying, even in the Jacksonburg Formation: "The larger [quarry] a short distance northwest of the mill is within the cement-rock belt. The stone was greatly crumpled and the amount of calcite and quartz vein matter was excessive. The stone from this main quarry was considerably below a 'mix' of $CaCO_3$. . . . The smaller quarry lies within the cement-limestone belt but the stone is much poorer than that occurring in this belt in the Nazareth region." This may be why Franks sold the plant to Lehigh Portland in 1925, and that company closed it in 1930. (Dick Schwechten.)

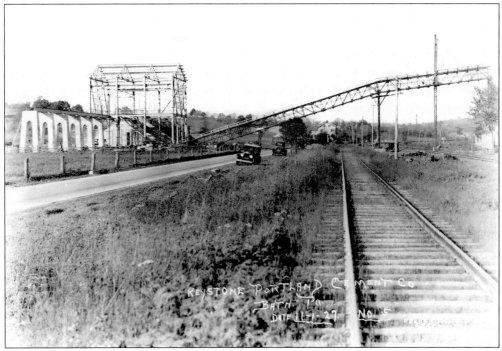

KEYSTONE PORTLAND CEMENT COMPANY CONSTRUCTION, 1927. The steel skeleton of the crusher house rises along the north side of Route 329 in this view (above) looking east toward Bath. The trestle, under construction to the left of the crusher, brought stone from the quarry, while the conveyer being built over the road carried crushed stone into the mill (below). (Keystone Portland Cement Company.)

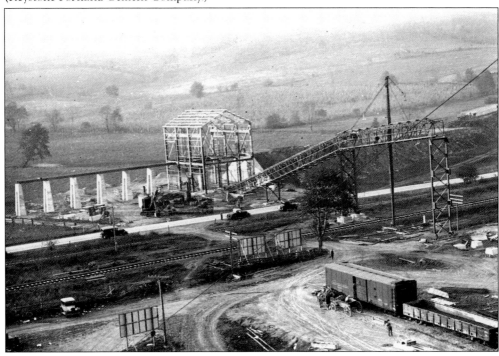

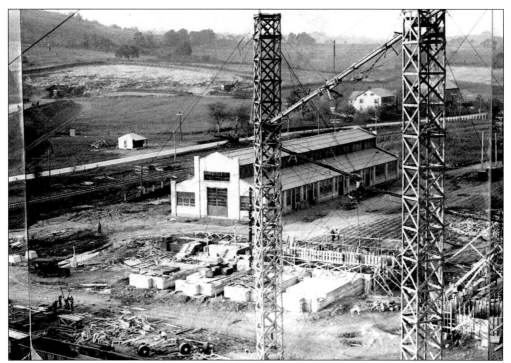

KEYSTONE PORTLAND CEMENT COMPANY CONSTRUCTION, 1928. The building in the center of the top photograph is still in use, housing the laboratory and other facilities. The plant's first kilns rested on the concrete foundations under construction in the picture below. (Keystone Portland Cement Company.)

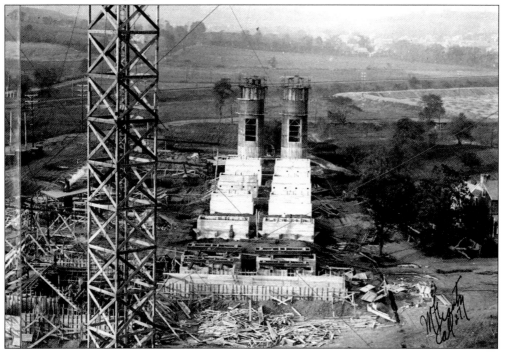

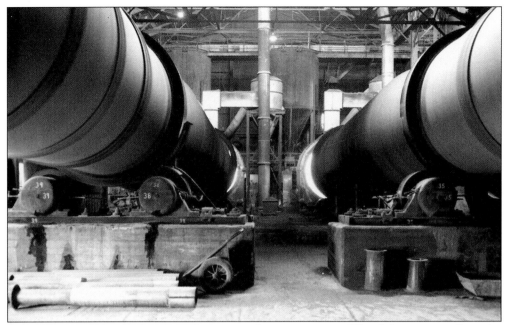

KEYSTONE PORTLAND CEMENT COMPANY CONSTRUCTION. The kilns were still under construction when the photograph above was taken in 1928. The plant has had several renovations and new structures erected over the years. Below is a set of storage silos that was built in the 1950s. (Keystone Portland Cement Company.)

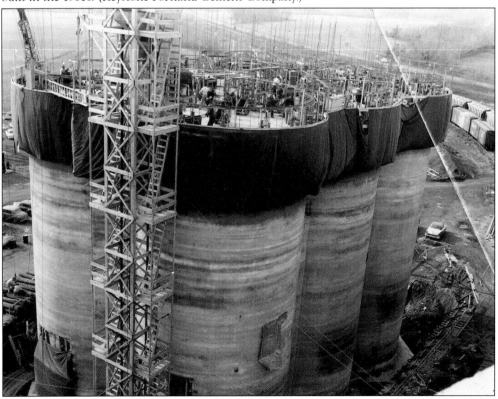

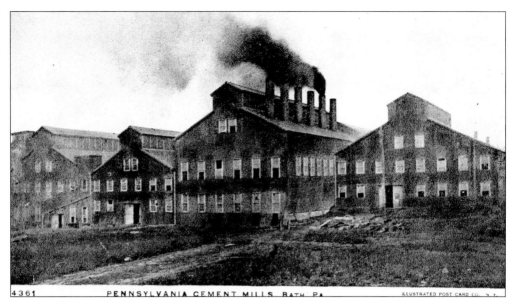

4361 PENNSYLVANIA CEMENT MILLS, BATH, PA. ILLUSTRATED POST CARD CO. N.Y.

PENNSYLVANIA CEMENT MILLS, BATH. Located about half a mile east of Bath along Route 248, the Pennsylvania Mill opened in 1903. Like its counterpart on the opposite side of Bath, this mill's quarry had large pockets of unusable clay and limestone. When the Pennsylvania-Dixie Cement Corporation began in 1926 out of a consolidation of the Pennsylvania, Dexter, and Penn-Allen Cement Companies, the quarry was abandoned and stone was brought via the aerial tramway from the former Dexter quarry. (Dick Schwechten.)

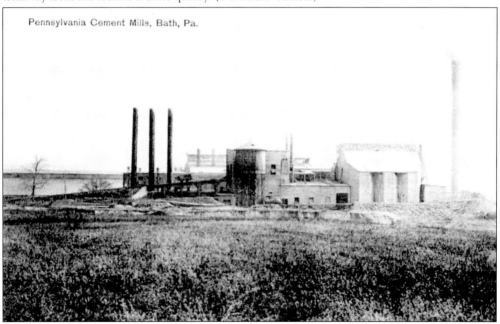

Pennsylvania Cement Mills, Bath, Pa.

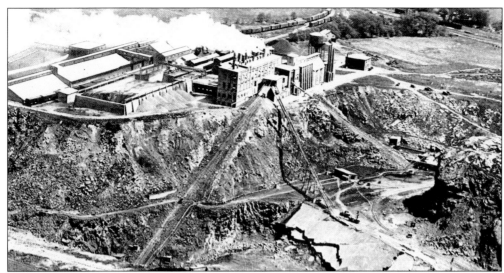

PENN-DIXIE PLANT NO. 6, 1930. The former Pennsylvania Mill became Plant No. 6, which operated until December 15, 1963. During the 1940s, it produced over 2 million barrels of cement a year. The remains of the original quarry are visible in this photograph, as well as the aerial tram delivering stone from Nazareth. The *Geology of Northampton County* of 1938 notes, "Unfortunately, the mill and other buildings are located on what appears to be the best stone on the entire property." (Kathleen Unger.)

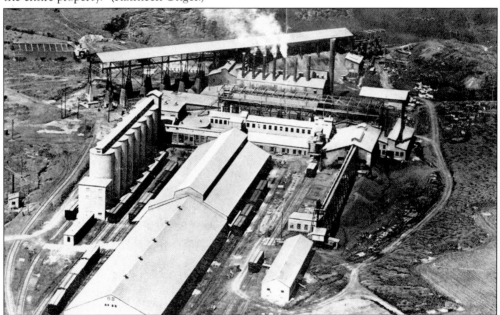

PENN-DIXIE PLANT NO. 5, C. 1920S. Originally the Penn-Allen Portland Cement Company, this plant began operations in 1903. At the time of this photograph, the mill had eight rotary kilns and produced 1.2 million barrels annually. The quarry in the upper right corner of the picture was little used; the stone burned in this plant arrived via the aerial tramway from the quarry at Plant No. 4 in Nazareth. The large roofed shed is where the tram buckets dumped rock. The plant closed on September 1, 1966. Cement silos, a storage hall office, and machine shop remain halfway between Bath and Nazareth. (Kathleen Unger.)

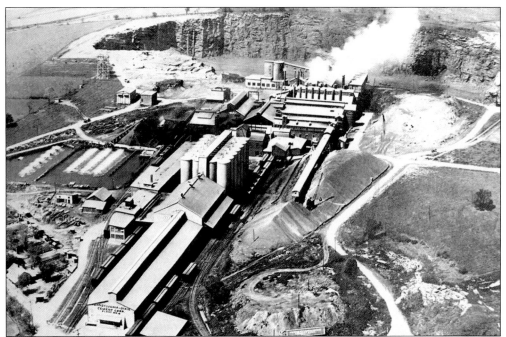

PENN-DIXIE PLANT No. 4, C. 1930. Now Essroc Plant No. 2, the Dexter Portland Cement Company opened the first mill on this site, just west of Nazareth, in 1901. Dexter was organized by George E. Bartol, the first president of Alpha Portland Cement, who recognized the top quality of Jacksonburg limestone at this site. When Penn-Dixie purchased the mill and quarry in 1926, the aerial tramway carried this superior stone to the company's other two mills. Plant No. 4 became a Coplay Cement mill in 1980, under the control of Paris-based Sociètè des Ciments Francais, and it was renamed Essroc Plant No. 2 in 1989. (Kathleen Unger.)

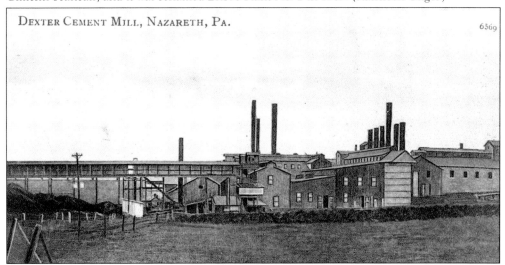

DEXTER CEMENT MILL, NAZARETH, C. 1905. This postcard of the early plant shows the raw mill on the right, the kiln department with six stacks for rotary kilns, and three tall stacks for the steam engines that powered the plant. The elevated conveyer gallery on the left carries cement clinker to outside storage. The name Dexter can still be seen painted on the eave of the cement storage hall north of Route 248. (Dick Schwechten.)

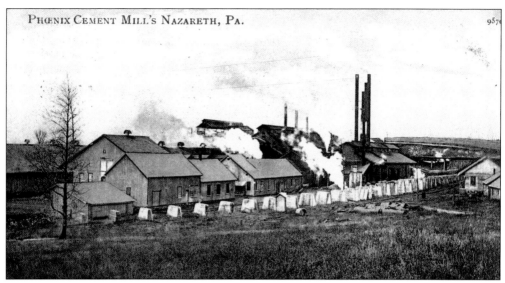

PHOENIX CEMENT COMPANY, NAZARETH. This is a postcard view of the village of Phoenix and the cement mill for which it was named. The company may have been so called because many of the investors were from Phoenixville, Pennsylvania. The plant made small quantities of natural cement, but the bulk of its output was portland cement. The company site was originally outside the western border of Nazareth, and the village of company-built houses to the north of the mill became known as Phoenix. The Lone Star Cement Company purchased the plant in 1928 and greatly expanded it. Lone Star sold out to Essroc, which designated the mill on this site Plant No. 3. (Dick Schwechten.)

FIRST CEMENT MILL, NAZARETH, 1905. The first cement plant in the Nazareth area took the name of the town and opened in 1899 as the Nazareth Portland Cement Company. (Dick Schwechten.)

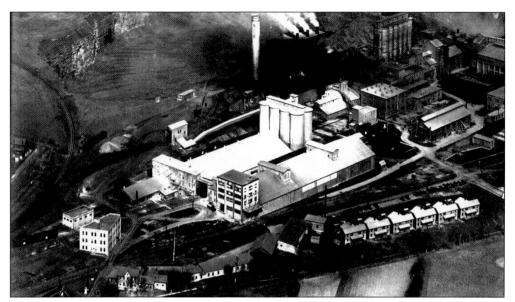

NAZARETH CEMENT COMPANY, MAY 11, 1929. The Nazareth Portland Cement Company reorganized in 1906 as the Nazareth Cement Company. This aerial photograph shows a very prosperous business that was producing about 5,000 barrels a year. The plant office was the mansion on the north along Route 248. The row houses were for plant bosses. Two railroads served the plant. Curving on the left is the Delaware Lackawanna; on the right is the Lehigh & New England Railroad track heading toward Martins Creek. Coplay Cement purchased Nazareth Cement in 1965, and in 1976 it became part of the French company now known as Essroc. (Kathleen Unger.)

COPLAY CEMENT COMPANY, NAZARETH PLANT, 1977. Shown shortly after it opened, this facility was the first new cement plant in the Lehigh Valley since Fred Franks opened the National Mill on Brodhead Road in Hanover Township in 1935. Financed by the French owners, Sociètè des Ciments Francais, it had the latest equipment, including a 17-foot-diameter, 284-foot-long kiln with a capacity of over 4,000 tons per day. The exhaust stack is 230 feet tall. The plant, continually being upgraded, is now Essroc Plant No. 1. (Dick Schwechten.)

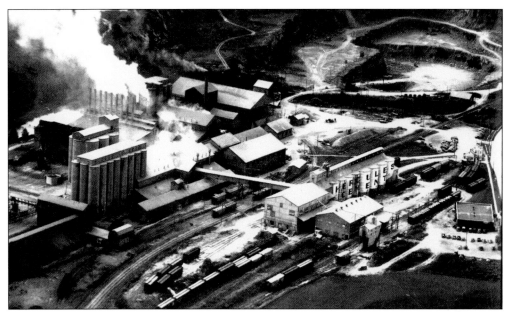

HERCULES CEMENT COMPANY. The easternmost of the current plants in the Lehigh District is on this site in Stockertown. Currently a modern operation owned by the Italian company Buzzi Cement, it had a checkered history. Construction began in 1906 as Atlantic Portland Cement, in conjunction with the Northampton Portland Cement plant half a mile to the east. The financial panic of 1907 stopped all activity until Morris Kind organized the Hercules Cement Company of Philadelphia in 1917. Operations began with twelve 7- by 125-foot kilns. The cement silos shown in this c. 1950 photograph were constructed and decorated with the company name in 1926. (Hercules Cement Company.)

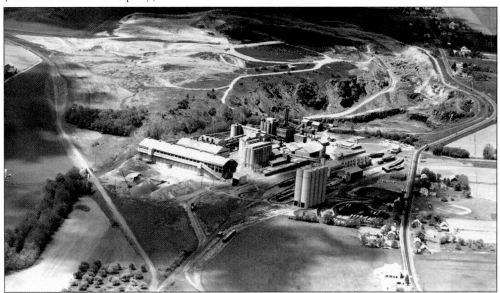

HERCULES CEMENT COMPANY. After World War II, there was a shortage of cement, and most companies expanded and modernized in the 1950s. W. R. Bendy Cement Engineers of St. Louis designed a plant with two 12- by 280-foot kilns and added a third in 1956. In 1957, the company became a division of the California-based American Cement Company. (Hercules Cement Company.)

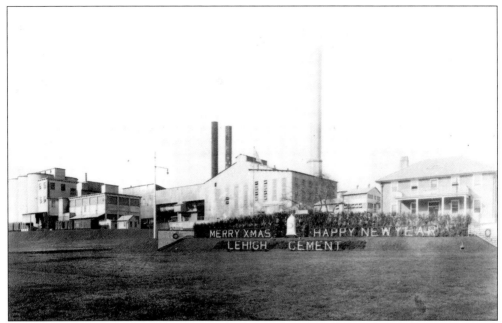

LEHIGH PORTLAND CEMENT, SANDT'S EDDY, C. 1930. Built by Fred B. Franks in 1923, the plant was incomplete when Lehigh Portland acquired this plant as well as the Bath Portland Cement mill in 1925 and began operating it in 1926. By 1930, the plant had three 160-foot-long kilns. On March 26, 1942, thirty-one men died in the plant's quarry when 20 tons of freshly delivered dynamite exploded during preparation for a blast. It was the worst accident in the history of the cement industry in the Lehigh District. The plant was closed in 1960 and was converted by the Con Agra Flour Milling Company, though the words "Lehigh Cement" in the bank are still visible. (Hunter-Martin Settlement Museum.)

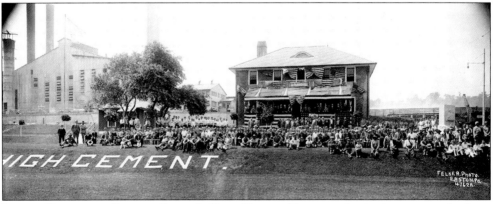

LEHIGH PORTLAND CEMENT, SANDT'S EDDY PLANT. Company dignitaries pose on the front porch of the plant office while workers and families gather on the lawn for the dedication of the coveted safety trophy, visible on the right. Over the years, the trophy has disappeared. (Hunter-Martin Settlement Museum.)

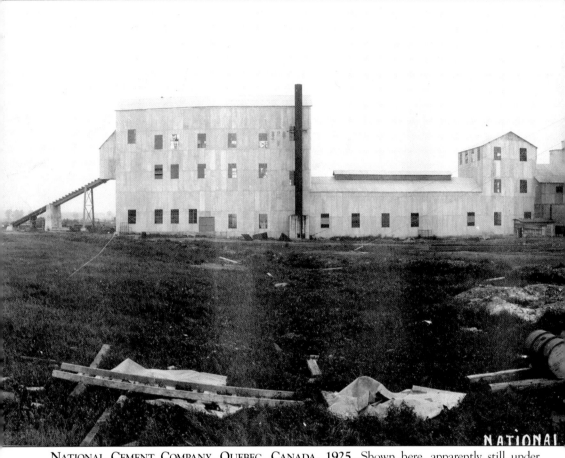

NATIONAL CEMENT COMPANY, QUEBEC, CANADA, 1925. Shown here, apparently still under construction, National Cement Company, Ltd. of Canada installed Bradley pulverizers in this plant. Many of the Lehigh Valley businesses which manufactured machinery and equipment for the

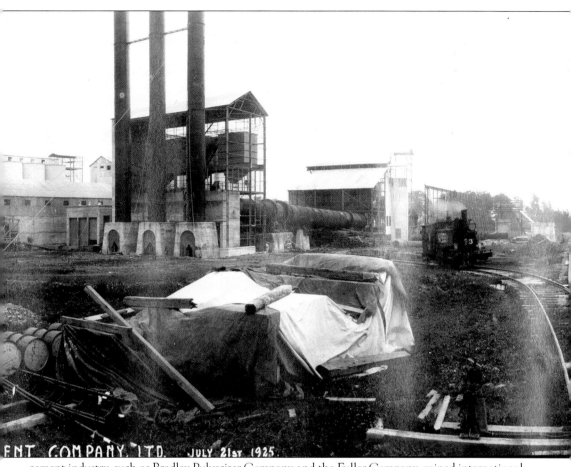

cement industry, such as Bradley Pulverizer Company and the Fuller Company, gained international reputations. (Bradley Pulverizer Company.)

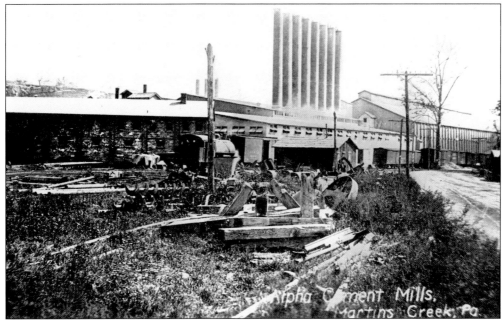

ALPHA CEMENT PLANT NO. 4, MARTINS CREEK. The buyer was Alpha Portland Cement, which rebuilt the plant with eight 60-foot kilns and restarted operations in 1908. The plant, along Route 611, was designated No. 4 and operated until 1964. The storage silos still stand alongside the road, but the landmark 300-foot smokestack was taken down in January 1994. (Ron Wynkoop Sr.)

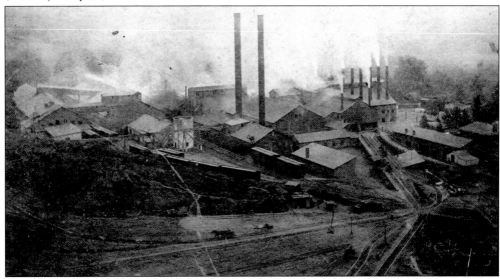

ALPHA CEMENT PLANT NO. 3, MARTINS CREEK. This plant was originally constructed in 1899 by the William Krause and Sons Portland Cement Company, but the company was beset by constant financial problems and suffered a disastrous fire in late 1900. After a shareholders revolt, the company reorganized as the Martins Creek Portland Cement Company in 1901. The plant was taken over almost immediately by Alpha Portland, which designated the mill No. 3, although the Martins Creek name persisted until 1908. Plant No. 3 operated until 1929. (Hunter-Martin Settlement Museum.)

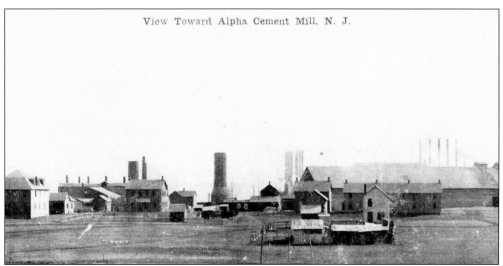

View Toward Alpha Cement Mill, N. J.

ALPHA PORTLAND CEMENT COMPANY, ALPHA, NEW JERSEY. Alpha Portland Cement began in 1895, when the Whitaker Cement Company reorganized after the death of Thomas D. Whitaker, son-in-law of George Ormrod. The firm's new name, Alpha Portland Cement, was taken from the brand name of Whitaker's chief product, Alpha-Omega cement. The company eventually built a second mill near the first one. The original plant on this site was the Bonneville Portland Cement Company, the second mill in the Lehigh District and the first in New Jersey to employ rotary kilns, which were installed in 1891. Alpha Cement's New Jersey plants were both closed by 1915, but the name lives on in the community of Alpha. (Above, Dick Schwechten; below, Ron Wynkoop Sr.)

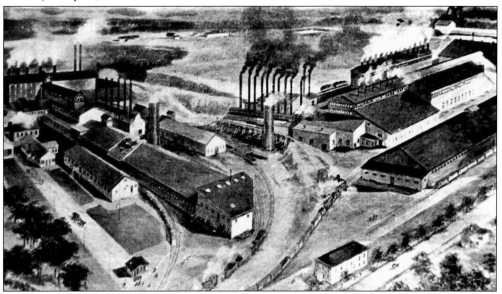

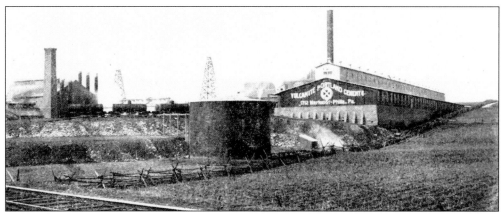

VULCANITE PORTLAND CEMENT MILLS, ALPHA, NEW JERSEY. Like the short-lived William Krause and Sons Portland Cement Company in Martins Creek (whose mills ultimately became Alpha Cement), Vulcanite Cement was begun by a Philadelphia street-paving company of the same name, which wanted to assure itself of a steady supply of cement. The plant went into operation in 1895 and was located just east of the Whitaker and Alpha plants. The company closed down in 1932. (Ron Wynkoop Sr.)

EDISON PORTLAND CEMENT COMPANY, NEW VILLAGE (STEWARTSVILLE) NEW JERSEY, C. 1936. The Edison Portland Cement Company was organized to build a plant in Warren County, New Jersey, which went into operation in 1902. The rotary kilns installed here were 80 feet long, half again as long as the industry standard at the time, and 10 feet in diameter. In 1909, Thomas Edison was granted a patent for kilns 150 feet long. In addition, he improved processes for grinding and crushing both stone and coal (which boosted efficiency) and is reputed to have been the first to promote use of the steam shovel in quarries. Edison Cement operated until 1942. (Ron Wynkoop Sr.)

Four

MAKING AND
MOVING CEMENT

A large industry like cement tends to spawn and support other businesses, which supply its needs. Some of the Lehigh Valley's large industrial businesses came into being to make products like kilns and crushers needed by the cement industry. Others expanded their own manufacturing line because they saw a cement industry need and filled it.

On the other hand, the valley's transportation system, particularly the railroads, was already set up to move one large bulky cargo—coal—and quickly adapted and expanded to take on cement as well. The railroads were the main carrier of both bulk and bagged cement until the late 1950s. Then, a change in trucking regulations triggered the switch to highway transport.

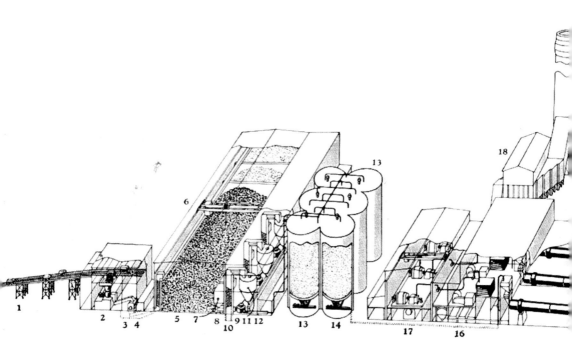

1—Trestle over which cars of raw materials (limestone in this case which will be mixed with shale or slag) enter plant.

2—Gyratory crushers reduce stone to 5½-inch size.

3—Rotating hammer mills further reduce it to ¾-inch pieces.

4—Electric-driven conveyors carry it to raw material storage.

5—The storage holds thousands of tons.

6—Traveling crane transports crushed material to feed hoppers.

7—Hoppers pass it on to the feeders.

8—Automatic feeders, controlled by chemists, proportion the different raw materials to secure exact chemical mixture required.

9—Grinding mills in which steel balls pulverize the mix to fine powder. Material is dried during the grinding process.

10—Elevator lifts the partially ground raw mix to air separators.

11—Air separators segregate material into fine and coarse particles. The fine goes to compressed air pumps; the coarse goes to the mill to be reground.

12—Air pump raises pulverized materials through pipes to blending tanks.

13—Blending tanks in which the powdered raw materials are intimately mixed.

14—Materials are pumped from tanks to kiln hoppers.

15—In long kilns—the largest rotating machinery in industry—intense heat, produced by blasts of powdered coal, all but melts the powdered raw materials and transforms them into new chemical compounds after which the material is discharged in the form of clinker about the size of marbles.

16—Waste heat boilers through which gases from the kilns pass.

17—Power plant in which steam from waste heat boilers passes through turbo-generator to produce electric power.

18—Gases pass through precipitator which removes the dust.

SCHEMATIC OF A CEMENT MILL, UNIVERSAL ATLAS COMPANY. This diagram appeared in a Universal Atlas publication in the mid-1930s. However, the process of making cement is

OF CEMENT MAKING

of buildings and machinery in a cement plant

Universal Atlas Cement Co.

United States Steel USS Corporation Subsidiary

Chicago	New York	Philadelphia	Boston	Albany
Pittsburgh	Cleveland	Minneapolis	Duluth	St. Louis
Kansas City	Des Moines	Birmingham	Waco	

Concrete for Permanence

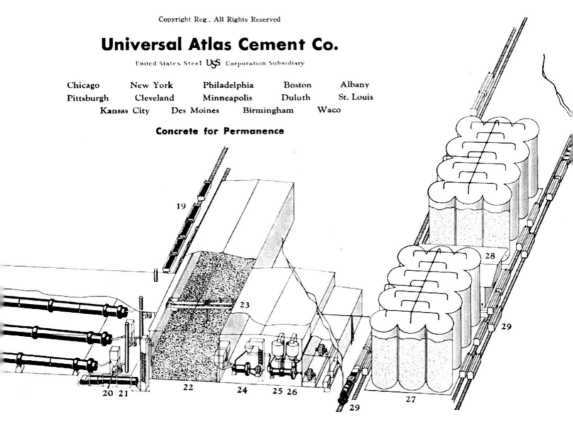

19—Coal drops from cars into bins.

20—Unit coal pulverizers grind coal finer than flour. Moisture is removed in the pulverizers by utilizing surplus heat from clinker leaving the kiln.

21—Clinker cooler receives red-hot clinker from kiln and cools it before storage.

22—Covered storage holding large quantity of clinker helps to insure steady production of cement.

23—Crane carries clinker to feed hoppers.

24—Grinding starts again, this time on portland cement clinker. Gypsum is added to regulate setting time. Preliminary mills grind clinker and gypsum to fineness of sugar.

25—Tube mills pulverize the preliminarily ground clinker into cement so fine that it will go through a sieve that will hold water.

26—Air separators separate cement into coarse and fine particles; the coarse is reground, the fine goes to cement storage via air pump.

27—Concrete storage tanks holding several hundred thousand barrels of cement guarantee users adequate supplies even in rush periods.

28—Packing and loading plant where automatic weighing and packing machines fill cloth sacks or paper bags with cement for shipment. Cement is shipped in bulk also.

29—Loading cement onto cars.

essentially unchanged today. (National Canal Museum.)

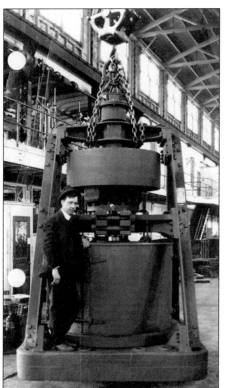

BRADLEY PULVERIZER. The Bradley Pulverizer Company's origins were in the fertilizer business. Robert Lesley and John Eckert visited the company's phosphate rock grinding plant in Wymouth, Massachusetts, and were so impressed by the Griffin Mills they were building and using there that Lesley promptly ordered one and installed it at his American Improved Cement plant in Egypt. This was the first Griffin Mill used for cement. It remained in service until around 1920. The company relocated to Allentown in 1886 to serve the cement industry and went into business under the name Bradley Pulverizer Company. (Bradley Pulverizer Company.)

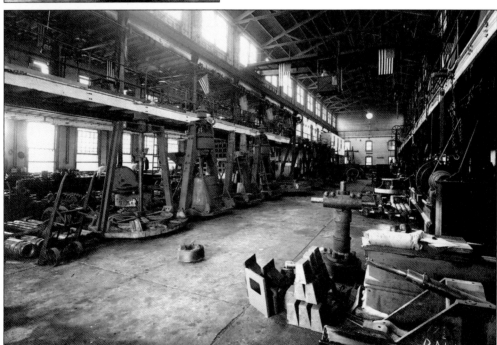

BRADLEY PULVERIZER COMPANY, ALLENTOWN, C. 1920. The company has moved beyond building mills for the cement industry to producing products for use throughout the minerals industry. (Bradley Pulverizer Company.)

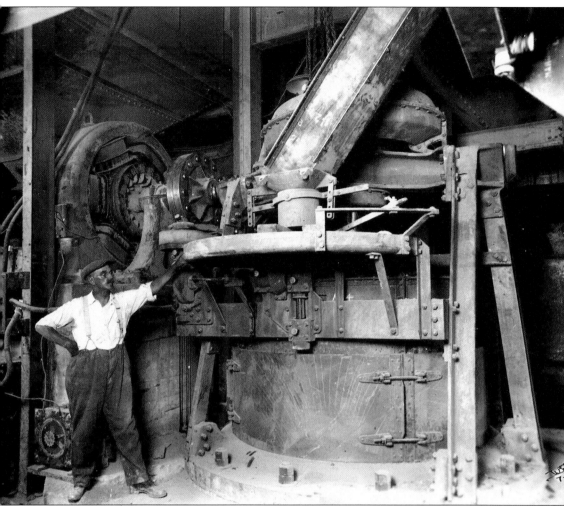

A BRADLEY PULVERIZER AT WORK, JULY 23, 1922. In his book on the history of the American portland cement industry, Robert Leslie recounts the story of Thomas Whittaker, founder of the first portland cement company in New Jersey, spending two days and two sleepless nights on the hill above American Cement, listening to the "booming noise of the constantly revolving Griffin Mill." According to Leslie, "When at the end of that time the mills were still rolling along merrily and he had heard no stoppage, he went home and put in his order for similar mills." Bradley's Griffin Mills set the standard for crushing and grinding machinery in the cement industry. (Bradley Pulverizer Company.)

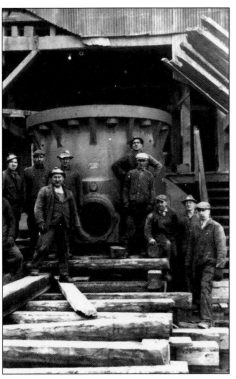

CRUSHER. A crew flanks a crusher, made by Traylor Corporation of Allentown, in a photograph taken at Lehigh Portland's Fogelsville plant on April 15, 1936. (Roy Lehr.)

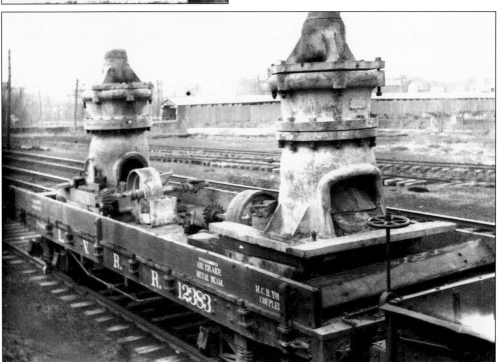

FULLER LEHIGH MILLS. Two Fuller Lehigh mills taken out of service sit on a Lehigh Valley Railroad flatcar alongside Whitehall Cement. The covered bridge between Northampton and Cementon is visible in the background. (Dick Schwechten.)

FINISH MILLS. Finish mills are the last stop for cement. Clinker, the marble-sized lumps of cement produced by the kiln, is first mixed with gypsum and ground down to the fineness of sugar. Tube mills then grind it down to the point that it is so fine it will pass through a sieve that holds water. Air separators then push the finest-ground cement out and send the coarser pieces back for more grinding. The photograph to the right, from an Alpha mill in Martins Creek, shows the air separators. The photograph below, taken on September 22, 1928, shows the newly installed Lehigh Mill at the Edison Cement plant in New Village. (Below, Ron Wynkoop Sr.)

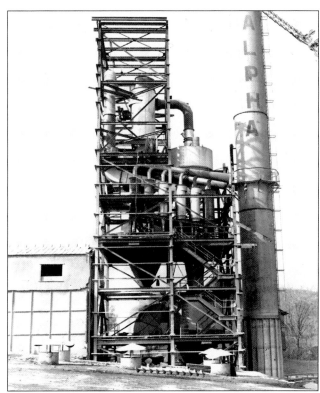

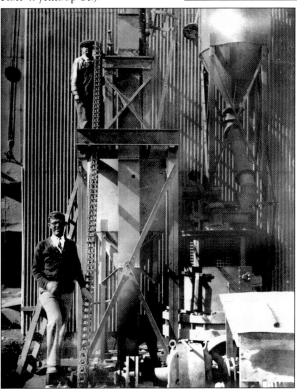

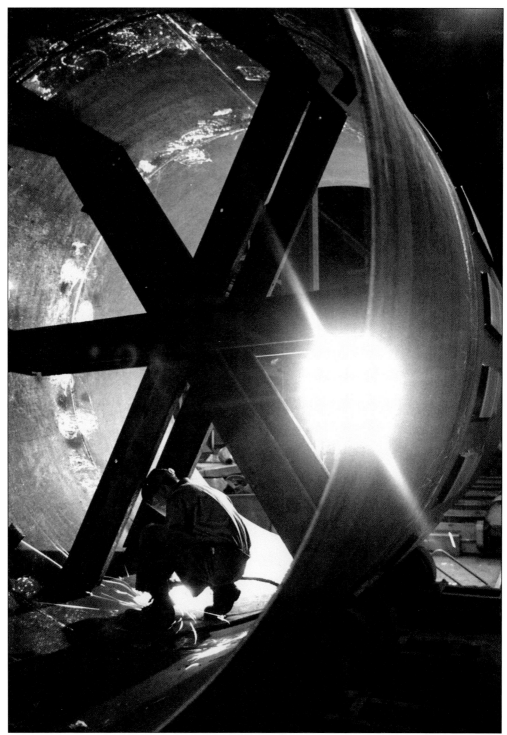

KILN SECTION UNDER CONSTRUCTION. A Fuller Company welder works on a kiln section at the Fuller plant in Allentown. Kilns are constructed in 30- to 40-foot-long sections and then assembled and completed on site. (F. L. Smidth Company.)

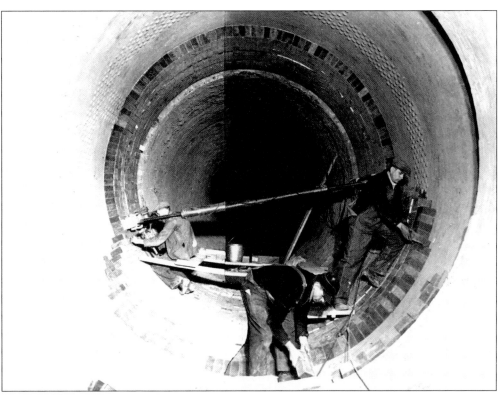

INSIDE A KILN. Here are two views of the inside of a kiln. In the photograph above, workers reline a kiln with fire bricks. At right is a view of the upper end of a kiln. The teeth fixed to the sides, and the chain, serve both to turn and rotate the load and to distribute the heat evenly through it. (Keystone Cement Company.)

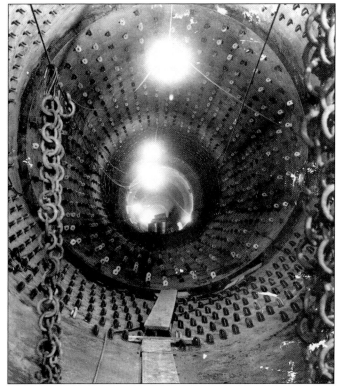

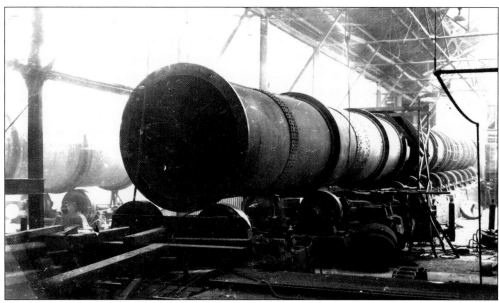

KILNS UNDER CONSTRUCTION. Two kilns are under construction at Edison Cement on July 4, 1928. A 1926 Edison publication describes 150-foot-long kilns, 8 feet in diameter. These kilns, also shown in the photograph at the top of page 65, appear to be larger. Thomas Edison received a patent for the 150-foot kiln in 1909, banishing doubts that a tube longer than 60 feet would warp. Edison's kilns, coupled with his innovations in stone grinding and coal pulverization, produced more than four times as much clinker than the 60-foot kilns. (John Metroke.)

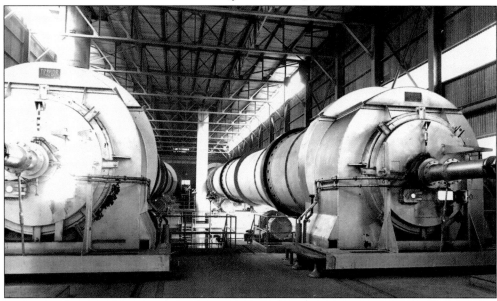

KILNS, LONE STAR CEMENT, NAZARETH. Two Traylor rotary kilns, 300 feet long and 11 feet 3 inches in diameter, are ready for work at Lone Star Cement on August 13, 1958. Traylor Engineering and Manufacturing, which had been in the cement and mining equipment business since 1902, was acquired by Fuller Company the following year. Fuller itself became a subsidiary of F. L. Smidth Company, a Danish company with a long history in the cement industry, in 1990. (F. L. Smidth Company.)

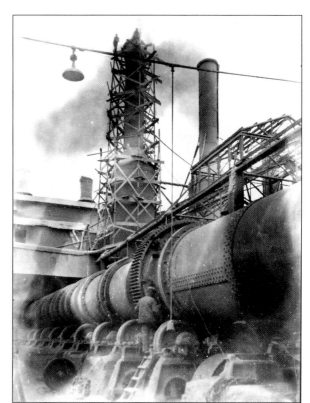

TWO VIEWS OF EDISON CEMENT. In the photograph to the right, taken in November 1928, workers dismantle a kiln stack, possibly as part of the installation of the kilns pictured on the previous page. Note the height of this kiln relative to the man alongside. The picture below, dated July 30, 1930, shows starting equipment, which initiated the rolling action of the crushers and kilns. (Ron Wynkoop Sr.)

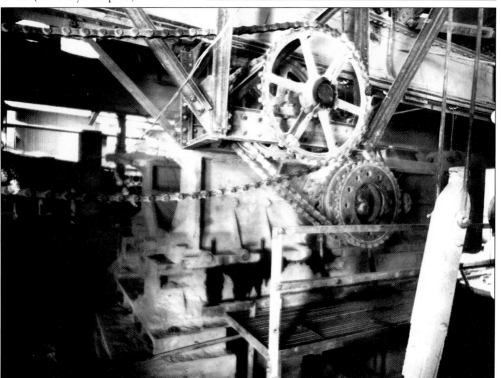

"DRAWING OFF" FINISHED CEMENT. In this stereoscope view, a Lehigh Portland worker is moving a cart that was used to pull out finished cement from a stock house to be packed and shipped. The cement, which had to be pulled because finished cement does not flow, was drawn through the small door at the right, dumped through the grate, and pulled by a screw conveyor. (Lehigh County Historical Society.)

ATLAS PORTLAND CEMENT BARRELS. Barrels that held 400 pounds of cement were the first containers for finished cement, and for many years, plant output was measured in barrels. Later, barrels were replaced by cloth bags and later by paper bags. (National Canal Museum.)

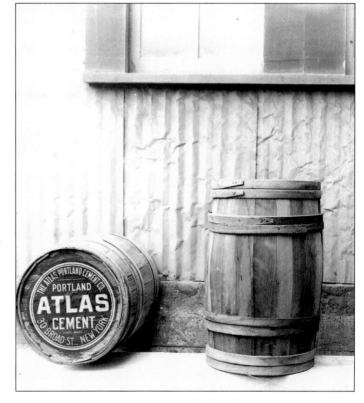

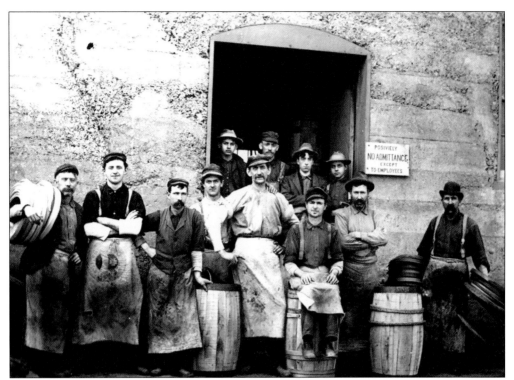

CEMENT WORKERS. Coopers at Alpha Portland (above) pose outside their workshop at the plant in New Jersey in this 1895 photograph. Note the man second from the left wearing an apron made from a cement sack. Below, packers pause in their work at the Bonneville Cement plant in Northampton sometime in the 1890s. (Above, Ron Wynkoop Sr.; below, Lehigh County Historical Society.)

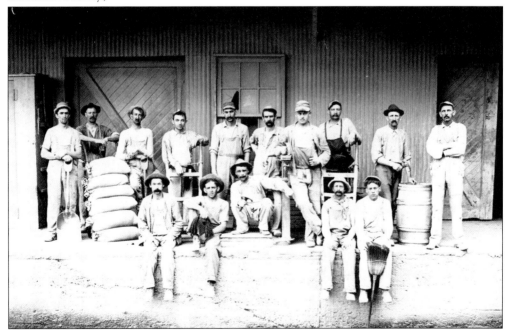

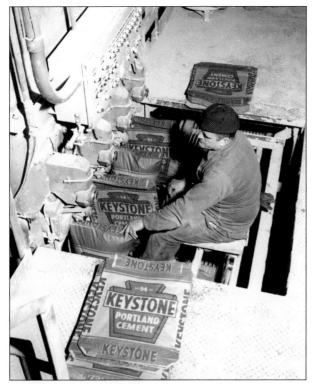

BAGGERS. Baggers are at work at Keystone (left) and Whitehall (below). By about 1900, measuring and bagging cement by hand was replaced by a system of chutes and scales. The operator placed a spout in a hole in the bottom seam of the bag and pulled a lever to open the spout. After 94 pounds of cement, measured by a scale under the bag, was deposited, the spout closed automatically, and the bagger tipped the bag onto a conveyor belt below. The weight of the cement forced a flap in the bag to close the fill hole, tightly sealing the bag. (Left, Keystone Cement Company; below, Lafarge.)

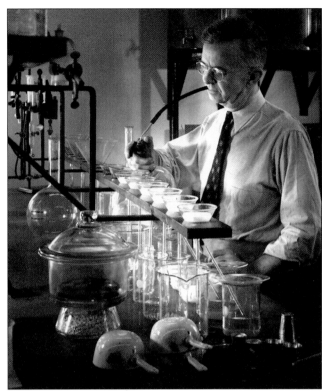

CEMENT SCIENCE. Scientific testing, measurement, and research are constant at a cement plant. The proper proportions of minerals are necessary to ensure the consistent quality of the cement. A chemist works in the laboratory of Universal Atlas Cement in Northampton in the photograph to the right. Below, two members of the research department at Fuller Company in Catasauqua work on the problem of air circulation in storage silos. (Right, National Canal Museum; below, F. L. Smidth Company.)

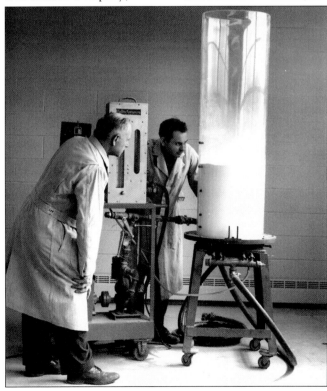

CEMENT SCIENCE. Atlas Cement Company chemists pose with their laboratory apparatus during the 1920s. Below, technicians work at the wet bench in the mineral separation lab at Fuller Company in Catasauqua around 1960. (Above, National Canal Museum; below, F. L. Smidth Company.)

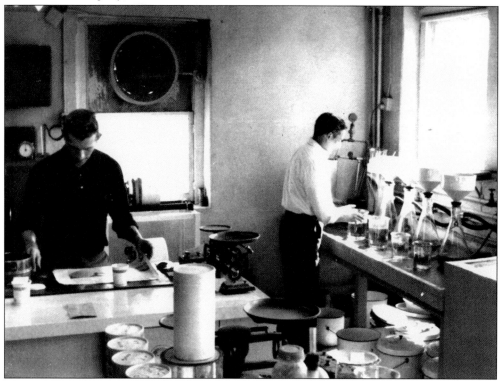

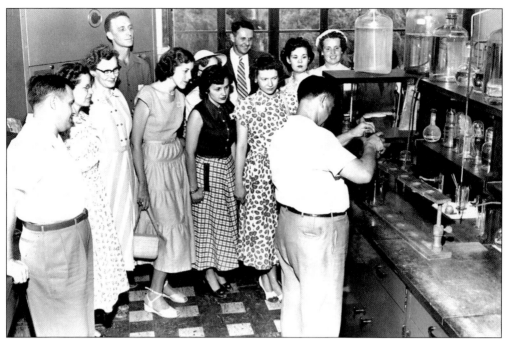

CEMENT SCIENCE. Keystone Cement workers' family members (above) watch Ernie Jacoby demonstrate a testing technique at the lab bench during a plant open house in 1950. In the Fuller Company lab (below), a unit for testing the permeability of dust collector fabric is shown. In the 1960s, efforts were begun to control air pollution in all phases of cement production. (Above, Edward Pany; below, F. L. Smidth Company.)

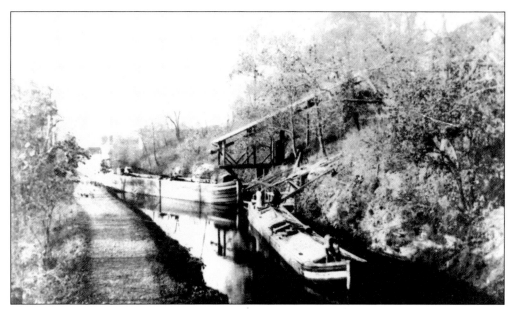

LOADING CEMENT ONTO A CANAL BOAT, C. 1905. Lawrence Portland Cement of Northampton was the only cement plant on the Lehigh Coal and Navigation Canal and the only one that shipped via boats. In this photograph, a loaded boat moves away from the chute, while another has been moved into position. This site is now part of the Tri-Boro Sportsmen's Club. (National Canal Museum.)

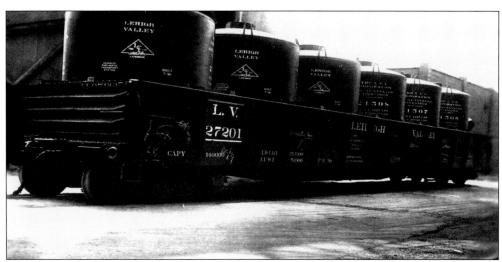

AIR-ACTIVATED CEMENT CANISTERS. Bulk transport of cement was almost entirely by rail until the mid-1950s. Several different ways of carrying cement by train car were developed, including these air-activated canisters aboard a Lehigh Valley gondola car. (Joe Yurko.)

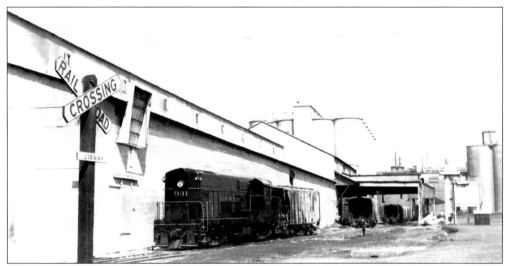

CEMENT TRAINS. A Delaware, Lackawanna and Western (DL&W) diesel with one covered hopper car waits alongside the Dexter Cement mill in Nazareth (above). The DL&W served most of the mills east of the Lehigh River, as did the Lehigh New England Railroad (below), shown in a publicity photograph taken in the 1930s in Bath. The bulk cement cars carried 70 tons. (Joe Yurko)

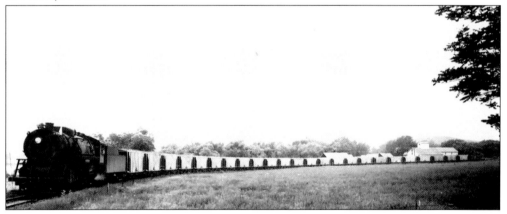

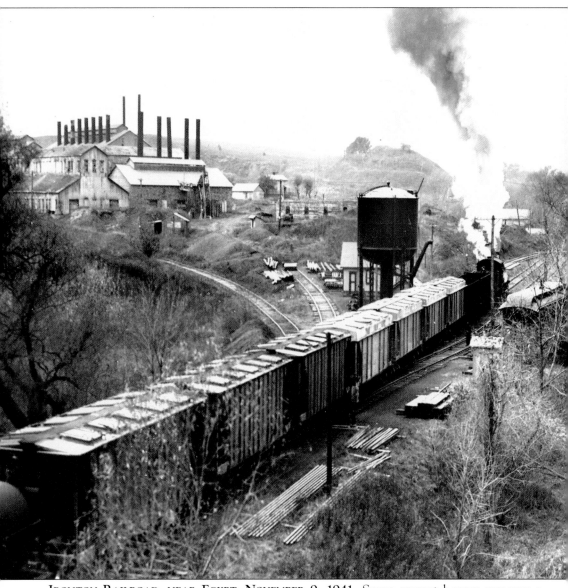

IRONTON RAILROAD, NEAR EGYPT, NOVEMBER 9, 1941. Seven cement hopper cars pass a siding to the central mill of American Cement in a photograph taken by Howard Cell. This site is now part of the Ironton Rail Trail and is in the Whitehall Township Passive Recreation area, just west of Route 145. The foundation of the water tower and the old train car on the far right still stand on the trail. (Joe Yurko.)

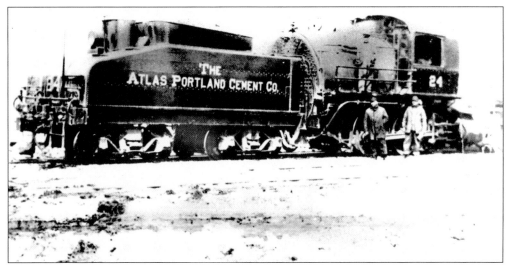

CEMENT COMPANY STEAM LOCOMOTIVES. Small but sturdy steam locomotives owned by the cement companies were used to move both inbound raw materials and outbound finished cement from the various sidings inside the plant to the connecting railroad company's tracks. Pictured above is an Atlas Portland Cement Company locomotive, and below is a saddle tank-style steam locomotive belonging to Lehigh Portland Cement. (Above, Tom Biery Collection; below, Lehigh Cement Company.)

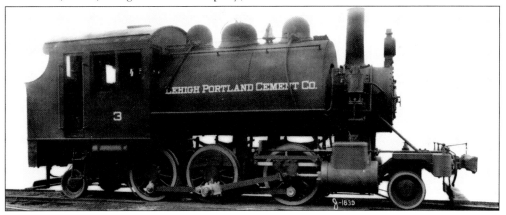

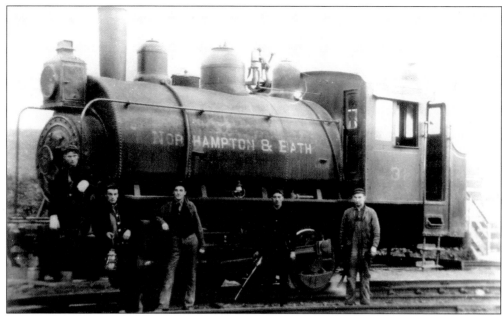

Two Northampton and Bath Railroad Locomotives and Crews. The Northampton and Bath Railroad Company (N&B) was chartered in July 1902. Its exclusive purpose was to serve the cement industry. The N&B had a single 8.5-mile stretch of track running from Northampton, where it linked to the Central Railroad of New Jersey, to Bath Junction, where it connected with the Delaware, Lackawanna and Western and the Lehigh New England. The N&B was the first American railroad to run only diesel electric locomotives. It shut down in 1984. (Tom Biery Collection.)

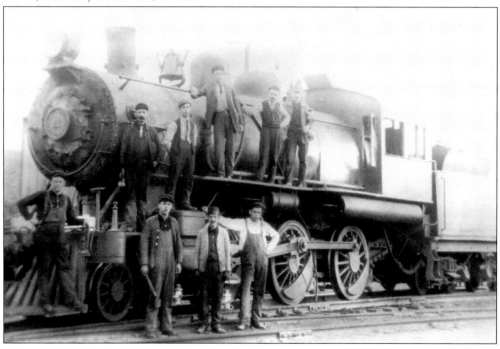

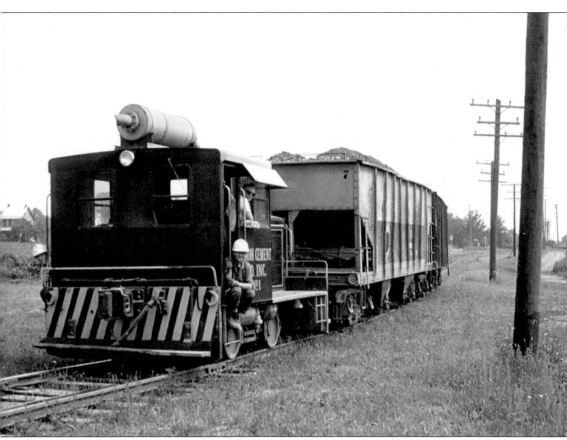

DRAGON CEMENT COMPANY SWITCHER, C. 1960. Three crew members guide an industrial switcher hauling open hopper cars loaded with crushed limestone at the Dragon (formerly Lawrence) Cement plant in Northampton. Shortly after this photograph was shot, the plant was sold to Martin-Marietta Corporation, which ran the plant until it shut down in 1983. (Tom Biery Collection.)

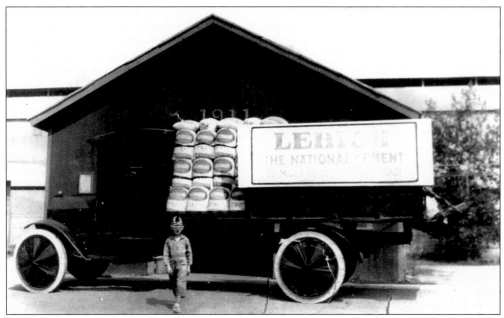

LEHIGH PORTLAND CEMENT COMPANY TRUCKS. A young boy stands alongside a solid-tired truck fully loaded with cement bags in this photograph taken in the 1920s (above). Heavy-duty pneumatic tires were only one of the innovations Mack had made by the time this 1946 model was delivered to the company. (Above, Lehigh Cement Company; below, Mack Truck Historical Museum.)

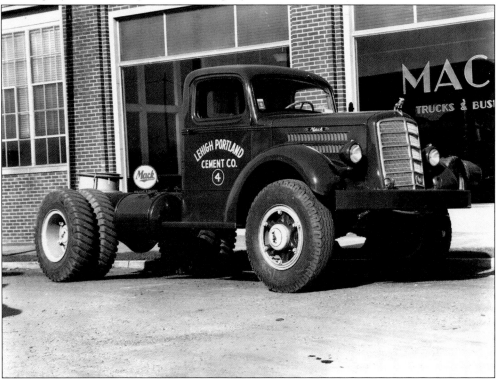

DUMP TRUCKS. The difference 25 or so years made is shown in these two photographs of dump trucks. Above, Whitehall workers pose by their early-1920s model, which boasted dual solid tires on its rear axle. Below, a Mack dump truck owned by Penn-Dixie Cement shows its stuff in October 1948. By then, the dump body was hydraulic and could carry 14 tons. (Above, Dick Schwechten; below, Mack Truck Historical Museum.)

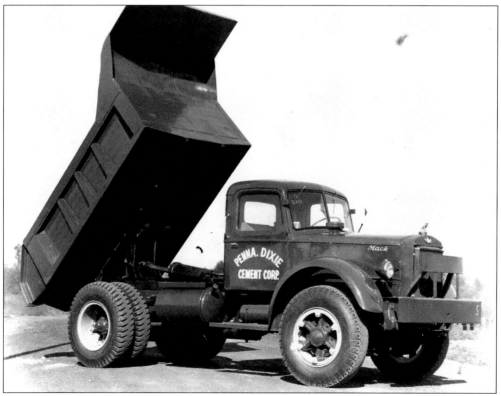

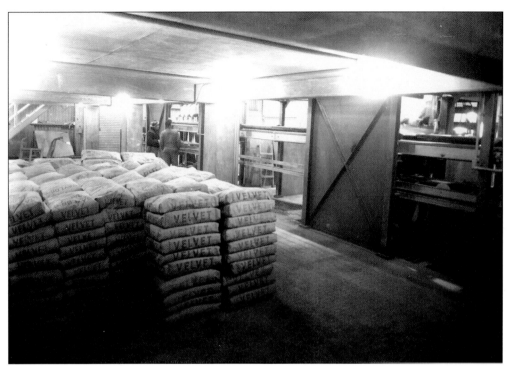

READY TO GO. Bagged in paper, Whitehall's Velvet brand cement sits in a warehouse waiting to be shipped. In the photograph below, a Mack truck delivers Edison bags to a street construction project, possibly as close to the plant as Washington, New Jersey. (Above, Dick Schwechten; below, Ron Wynkoop Sr.)

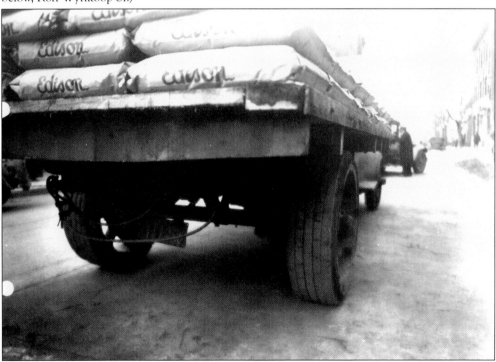

Five

LIQUID STONE

In his history of cement, Lehigh Portland president Joseph Young points out that the Great Pyramid of Egypt, one of the largest human-built structures of all time, took 100,000 men 30 years to build, while it took only seven years for 7,500 workers to construct the Grand Coulee Dam, which is more than four times larger. That was because the dam workers could pour thousands of cubic feet of concrete—liquid stone, in Young's words—every day.

Concrete (a mix of cement, sand, and gravel) made it possible for the first time in human history to build very large structures fairly quickly, without having to set one individual brick or stone upon another. This was revolutionary, with effects on modern life on a par with the discovery of electricity and the invention of the internal combustion engine. Concrete completely changed what humans could construct and also made it possible to control natural forces such as rivers in unprecedented ways.

Since the mid-19th century, the world's appetite for cement has grown immensely. Concrete is now so ubiquitous that it is impossible to imagine life without it. The photographs on the following pages are a small sample of how cement and concrete construction changed the face of the Lehigh Valley.

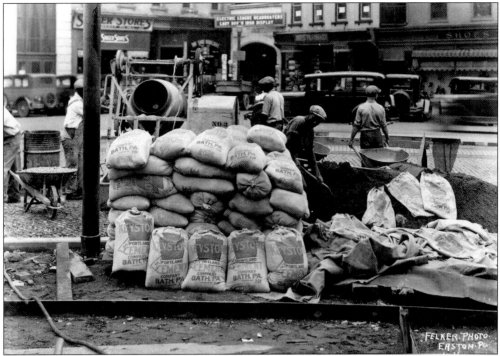

CENTRE SQUARE, EASTON, PENNSYLVANIA. City officials and Keystone executives stand on the newly installed sidewalk surrounding the Soldiers Monument on September 8, 1928, in the photograph below. Above, workers mix Keystone cement and gravel for concrete to replace the brick street surface of Centre Square. (Keystone Cement Company.)

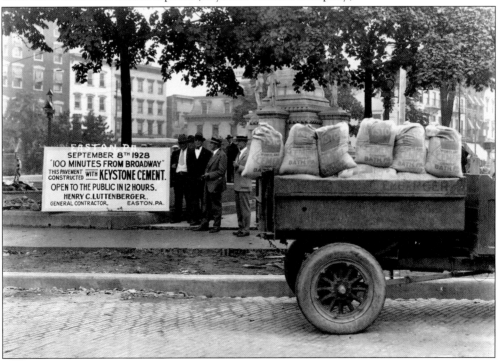

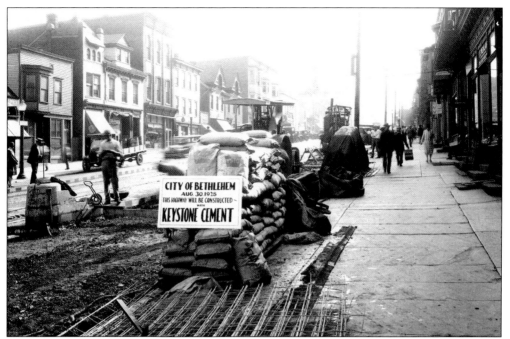

PAVING MAIN STREET, BETHLEHEM, PENNSYLVANIA, 1928. The newly opened Keystone Cement Company won the cement contract for street renovation in Bethlehem as well. Notice the steel reinforcing wire in the foreground. (Keystone Cement Company.)

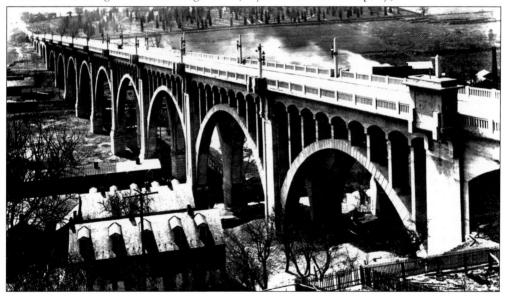

EIGHTH STREET BRIDGE, ALLENTOWN, PENNSYLVANIA. Harry Trexler was president of the Lehigh Valley Transit Authority, which built this 2,650-foot-long bridge between downtown Allentown and the south side of the city in 1912–1913. The trolley company's monumental bridge not only carried its cars safely over the flood-prone Little Lehigh River but provided a showcase for the portland cement made by another of Trexler's companies, Lehigh Portland Cement. The 110-foot-high bridge is now known as the Albertus Meyers Bridge in memory of the longtime conductor of the Allentown Band. (Joe Yurko.)

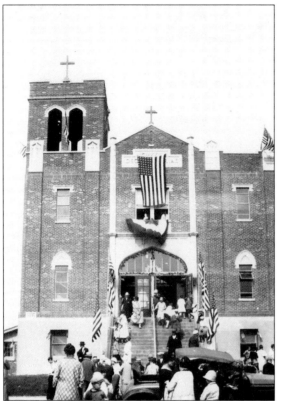

CEMENT BUILDINGS. It is not surprising that cement and concrete were major components of many buildings in Northampton. Below, the post office at the corner of 17th and Washington Streets, built in 1939, was the first concrete post office in the United States. The foundations of Blessed Virgin Mary Church, shown at left at its dedication in 1923, were built with cement donated by the Atlas, Lawrence, and Whitehall cement companies. Most of the parish's first members were immigrants lured by the prospects for steady work in the cement mills. Their trek from their homelands in eastern Europe is commemorated in stained-glass panels on the door of the church. (Left, Jane Spangler; below, Dick Schwechten.)

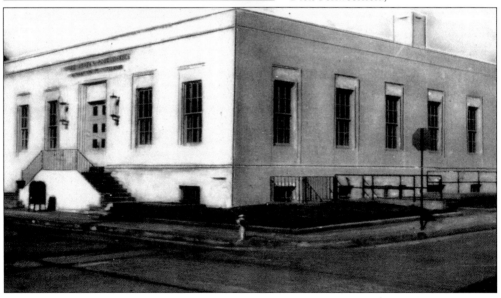

ROAD CONSTRUCTION. "The Concrete Mile," a stretch of New Jersey Route 57 between Stewartsville and New Village was paved with Edison portland cement in the 1920s (above), making this the first concrete highway in the state and one of the earliest in the country. Concrete and cement were intensively studied at Lehigh University, and many lab experiments were eventually tested under real world conditions, as shown in the photograph below, taken on old Route 22 somewhere between Allentown and Reading. (Above, Ron Wynkoop Sr.; below, Library of the Fritz Laboratory, Lehigh University.)

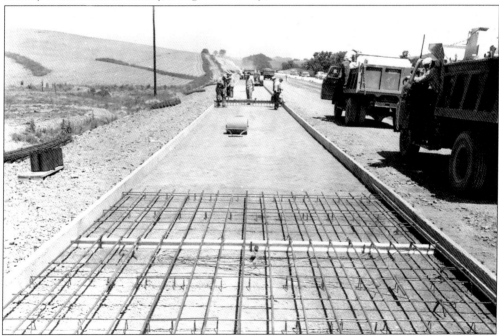

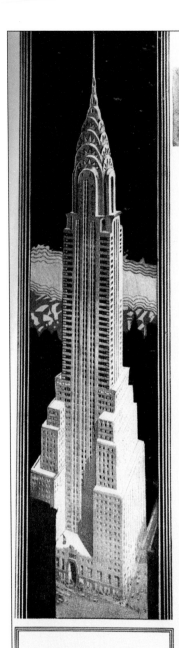

Beauty and Permanence

SLIM and serene—the Chrysler Building, highest in the world, rears its seventy-seven stories to the skies. Its austere outline an epic of classic symmetry. A beauty that is ageless.

Atlas White portland cement for terrazzo floors, preserves all required color effects to harmonize completely with any symbolic tracery desired. Likewise for non-staining mortar, for concrete art stone, for stucco, it has no peer.

For mass work, Universal portland and Atlas portland cement, of course. Over 100 million sacks went into new construction last year.

22

SOARING CEMENT. Skyscrapers would be impossible without concrete. So when the tallest building in the world, the Chrysler Building, opened in 1930, it was only natural that Universal Atlas Cement would open an office there. Interestingly, in this advertisement, the company touts its Atlas White cement, which was more commonly used for decorative purposes than heavy construction. (National Canal Museum.)

CEMENT GUN. The cement gun was developed in the early 1900s by taxidermist Carl Akeley, who needed a way to spray quick-drying plaster onto a wire frame. The possibilities for concrete construction with such a system caught the attention of engineer Clarence Dewey, who refined and developed the gun. In 1912, he and Allentown businessman Samuel Traylor bought the rights to the gun. Subsequently, Traylor opened the Cement Gun Company in Allentown. Gunite, the sand and cement mixture shot from the gun, was a major construction component of the Panama Canal. (Lehigh County Historical Society.)

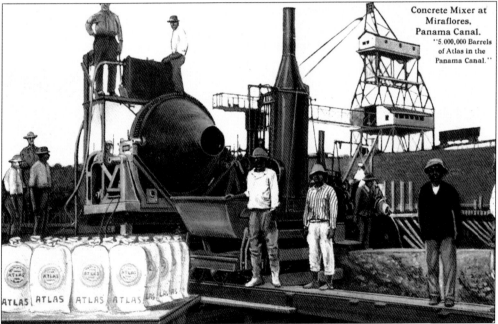

Concrete Mixer at Miraflores, Panama Canal. "5,000,000 Barrels of Atlas in the Panama Canal."

THE PANAMA CANAL. Construction of the Panama Canal posed a huge challenge to the American cement industry. Many companies supplied cement, but none at the level of Atlas Portland Cement. Their first five million barrels (nearly one-third of the company's average annual output) sent to the isthmus were accepted without a single rejection. This cement went into the building of the Gatun locks, dam, and spillway. Because of Atlas's excellent quality, another 10 million barrels were used to finish the canal. (National Canal Museum.)

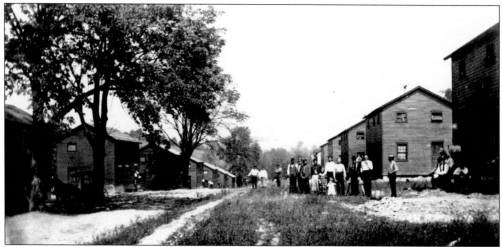

HOUSES THAT CEMENT BUILT. Despite the fact that they were producing one of the world's most durable building products, early cement workers were usually housed in rather frail-looking wooden houses like those shown above, built by Lehigh Portland in East Fogelsville in the early 1900s. These houses were replaced by more substantial frame structures (seen on page 110), which are now also gone; the line of trees parallel to Route 100 in Upper Macungie Park is all that remains of the neighborhood. Still standing as a testament to the strength of cement construction, though, are these houses in the Valley View neighborhood of Phillipsburg, New Jersey. In the 1920s picture below, they were under construction using Alpha cement. (Above, Carol M. Front Collection; below, National Canal Museum.)

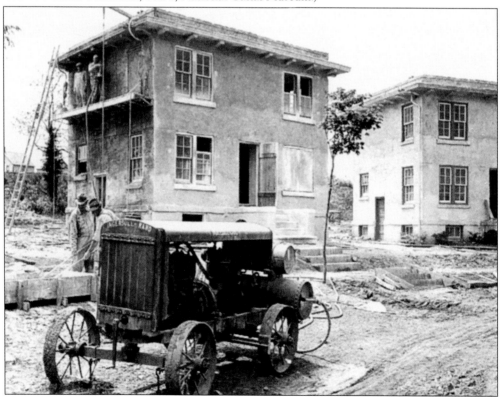

Six

WORKERS AND THEIR FAMILIES

The communities around cement mills became great melting pots, as new immigrants and their families mixed with people who had been Pennsylvanians for generations. Most of those towns, such as Bath and Nazareth, were old and established when the cement mills came. Others sprang up as company towns, such as Ormrod, or were collections of tiny settlements that mushroomed overnight into boroughs, such as Northampton. Whatever their origins, all these towns still retain much of the character—and most of the churches—brought by the people who came from Slovakia, Poland, Hungary, Italy, and other places to work in the cement plants.

Cement work was one of the dirtiest and most dangerous jobs a man could have above ground, and for a long time it did not pay very well. But the cement mills rarely lacked laborers, since most of them drew on an immigrant network that encouraged relatives and friends in their native lands to make the move to America.

By the early 1920s, the cement industry had become much more safety conscious, and winning the Portland Cement Association's handsome concrete trophy for an accident-free year became a matter of great pride for a cement plant. When a trophy was unveiled, or a new accident-free year recorded on it, families and local dignitaries were invited to large celebrations, which usually included an open house of the plant.

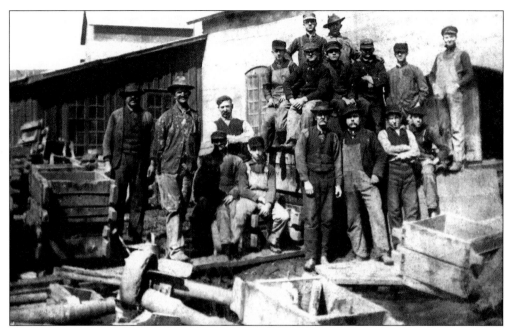

LEHIGH PORTLAND CEMENT COMPANY WORKERS. Two groups of workers, among the first employees of Lehigh Portland, pose in Fogelsville in the early 1900s. It is impossible to tell what sort of work the group in the picture above did. The men in the photograph below worked at the crusher. The only one whose identity is known is Martin Lehr, second from the left in the front row of the bottom photograph. (Above, Lehigh Cement Company; below, Roy Lehr.)

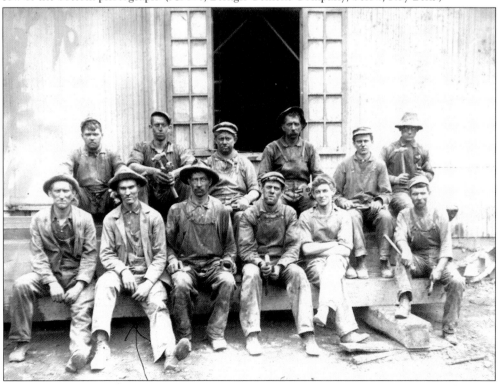

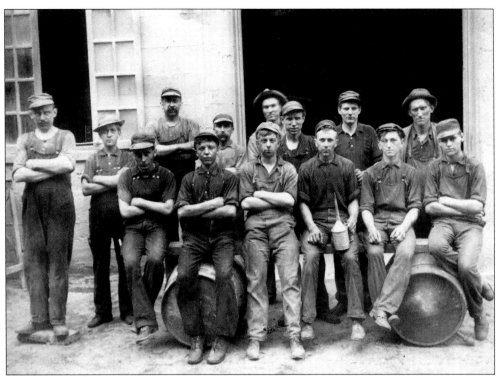

LEHIGH PORTLAND CEMENT COMPANY WORKERS. Martin Lehr is seen again, in the center of the back row, in the photograph above. It is interesting to note that the youngest workers in these photographs appear to be in their late teens. Despite the fact that laws regulating child labor were not widespread at that time, the cement industry did not employ children, possibly because the work was so physically demanding and so dangerous. The men in the photograph below are displaying tools they used to loosen blockages in the kilns and crushers. (Above, Roy Lehr; below, Lehigh Cement Company.)

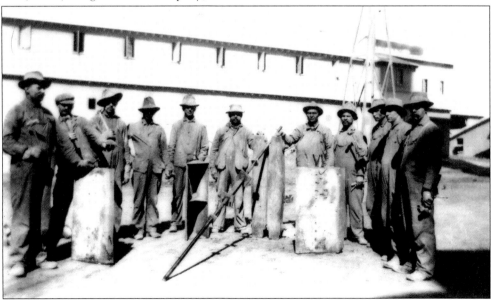

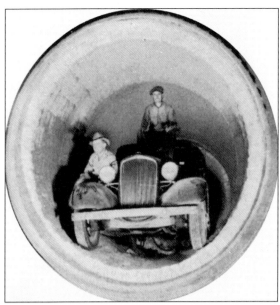

A Ride in a Kiln. This 1930s image shows two Universal Atlas employees proving an industry rumor that it was possible to drive a car through a kiln. Their joy ride through a kiln shut down for repairs was "slow, but thrilling" they told a company writer. (National Canal Museum.)

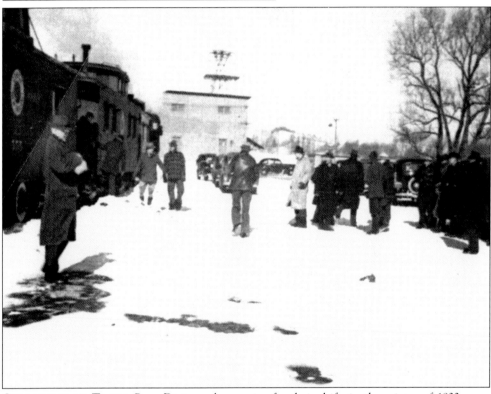

Commuting by Train. Penn-Dixie workers arrive for their shift, in the winter of 1933, on a Lehigh New England (L&NE) train. The L&NE did not run passenger cars, so fare-paying riders rode in the cabooses, two of which are shown in this picture. Since every cement plant was served by a railroad, many cement workers who did not live close enough to walk to work took the train. Some bought tickets, while others "rode the rods"—a free but dangerous trip—beneath the cars. (Kathleen Unger.)

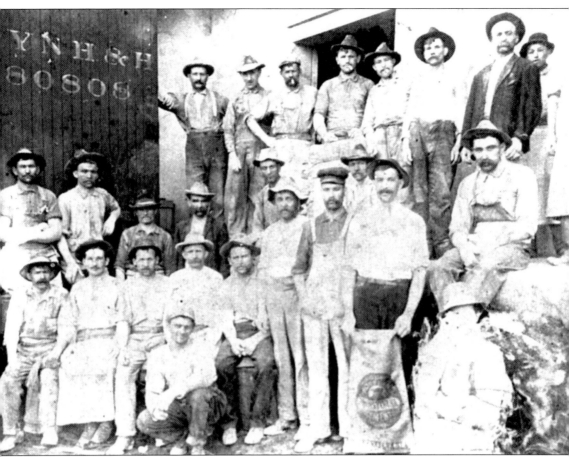

ATLAS CEMENT WORKERS. Men who may have been baggers and boxcar loaders pose alongside a New York, New Haven and Hartford Railroad car in this undated photograph. Perhaps as many as 75 percent of these men were immigrants, drawn from southern and eastern Europe by the promise of steady work and personal freedom. Atlas printed its employee handbooks in eight languages other than English. (Bath Museum.)

CEMENT WORKER CLOTHES. In the photograph to the left, an unidentified quarry worker poses in the days when stone was loaded by hand. His only protective gear is a thick vest and gloves. Below, Harry Purcell, a longtime Alpha Portland employee at the Martins Creek plant, shows off his coveralls. By the time Purcell was working, showers and clothes-changing facilities for workers were commonplace. (Left, Hunter-Martin Settlement Museum.)

CEMENT WORKERS. Not every cement employee had to work in dusty, noisy, and sometimes dangerous conditions. Essential work was (and is) also done in cement plant labs and offices. Below, Lehigh Portland Cement's company nurse poses with flowers and a smile at the Fogelsville mill. She is seen again on page 104. In the picture to the right, Arlene Frey Worzell smiles at the Penn-Dixie switchboard in the late 1950s. (Right, Kathleen Unger; below, Lehigh Cement.)

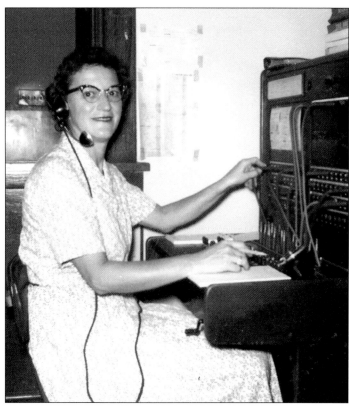

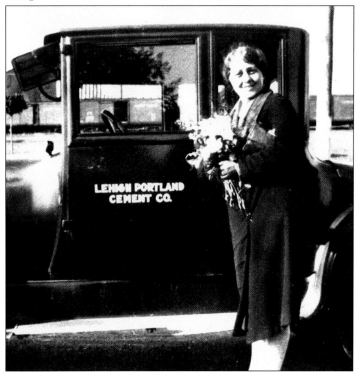

PENN-DIXIE EXECUTIVES AND STAFF, 1930S. Penn-Dixie executives and salesmen pose on the steps of their office building on Route 248, east of Bath, in the photograph above. The building, now the headquarters of Essroc, was a farmhouse when it became the offices of Pennsylvania Cement in 1903. It was expanded several times as the headquarters of Penn-Dixie Cement. Below, the office staff strikes a more playful pose on the back steps of the building. (Kathleen Unger.)

WOMEN WORKERS, 1930S. Penn-Dixie office workers pose on a workday in the photograph above and relaxing at a company picnic below. Women have never been a major presence in the cement industry, though female executives are moving up through the ranks in several cement companies. For example, Carla Eustache is the operations manager of the Lafarge plant in Cementon, and Lafarge has several other female managers. Historically, however, there have been few jobs for women. During the years when cement was shipped in cloth bags, women sewed and repaired them. The only other jobs open to female workers have been as office staff. Even today, only a handful of women work in the quarries or the actual plants. (Kathleen Unger.)

SAFETY AWARD, PENN-DIXIE PLANT NO. 4, 1937. The unveiling of a Portland Cement Association safety trophy or the addition of another date on its base (below) was a cause for celebration at a cement plant. Workers' family members and local community leaders were invited to the ceremonies, and, as the photograph of Penn-Dixie office workers above shows, everyone dressed in their Sunday best. (Kathleen Unger.)

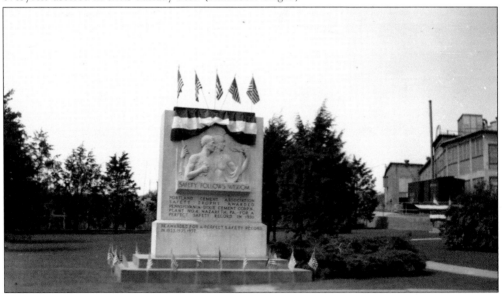

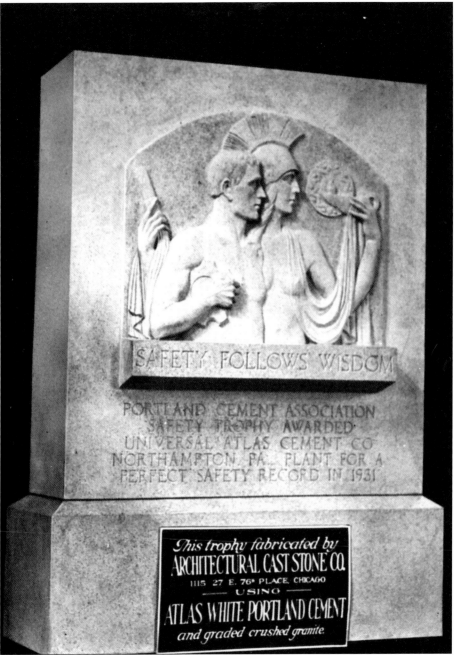

The sculpture bears the inscriptions:

SAFETY FOLLOWS WISDOM

PORTLAND CEMENT ASSOCIATION
SAFETY TROPHY AWARDED
UNIVERSAL ATLAS CEMENT CO
NORTHAMPTON PA. PLANT FOR A
PERFECT SAFETY RECORD IN 1931

This trophy fabricated by
ARCHITECTURAL CAST STONE CO.
1115 27 E. 76ª PLACE, CHICAGO
— USING —
ATLAS WHITE PORTLAND CEMENT
and graded crushed granite.

PCA SAFETY TROPHY. The Portland Cement Association began awarding safety trophies in 1924. The award is given to a plant that has no time-lost accidents during a year. "Safety Follows Wisdom" was designed by an Art Institute of Chicago team headed by the sculptor Albin Polasek and, when this picture was taken, was constructed of Atlas White portland cement. Once a familiar sight in cement communities, some of the markers have survived the mills that won them. Lehigh Portland's Ormrod plants' trophies are now in Saylor Park, Coplay, while both of Alpha Portland's PCA monuments are preserved along Route 611 in a grove of trees maintained by Eastern Industries. (National Canal Museum.)

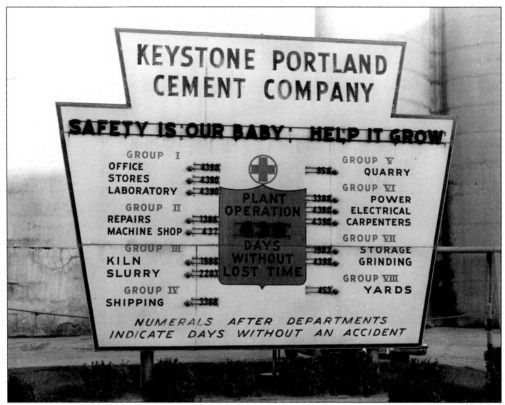

SIGNS FOR SAFETY. In an industry where blasting, crushing, volcanic heat, and moving thousands of tons of stone are the everyday conditions, worker safety is a major concern. Cement companies used signs and competitions between departments to keep safety awareness high. Keystone's 1950s-era sign above has a modern counterpart today in front of the plant on Route 329. Below, a sign at a Penn-Dixie mill used rhyming verse and electric lights to encourage its workers. (Above, Bath Museum; below, Kathleen Unger.)

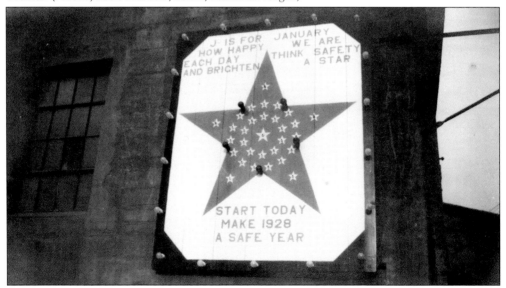

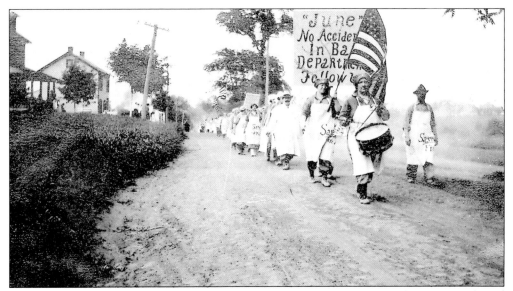

SAFETY PARADE, SAYLOR'S COPLAY CEMENT. Wearing aprons reading, "Safety First," male and female workers in the Coplay Cement bag department proclaim their pride in an accident-free June. The year of this parade is unknown. (Kate Raines.)

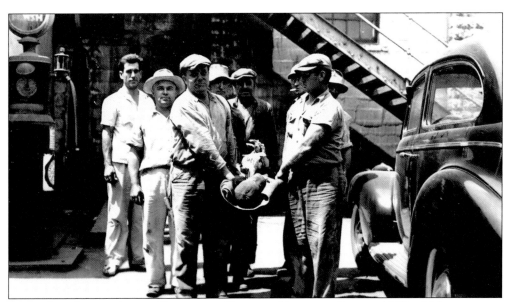

FIRST AID DRILL, ALPHA PORTLAND CEMENT, MARTINS CREEK, 1930s. Volunteers run through an emergency procedure drill, although their equipment appears to be little more than an improvised stretcher. (Hunter-Martin Settlement Museum.)

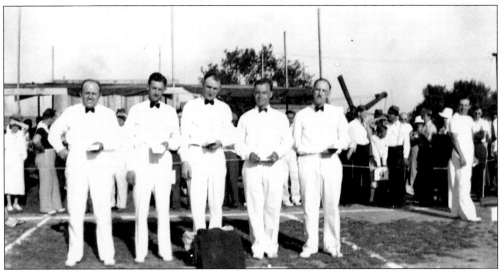

FIRST AID COMPETITION, PENN-DIXIE, 1938. A first aid team stands together (above) at an apparent competition at one of the Penn-Dixie plants in the 1930s. In the photograph below, teams (that may be working on volunteer "victims") hustle through a drill under the eyes of judges. First aid teams were set up in each area of the plant to give preliminary care to an injured worker. (Kathleen Unger.)

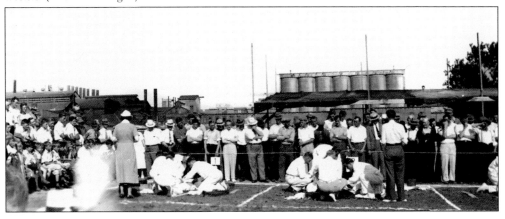

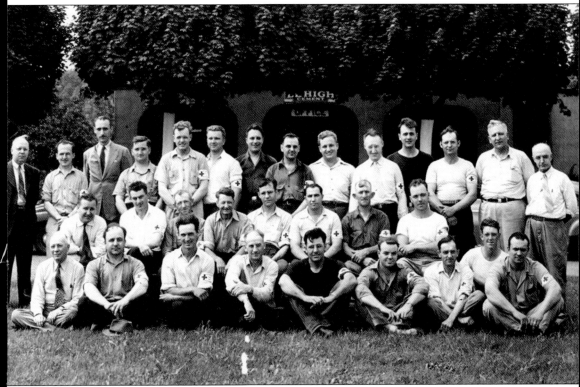

First Aid Committee, Lehigh Portland Cement. The safety crew at Lehigh's Fogelsville plant, wearing Red Cross armbands, poses with the company doctor in 1943. From left to right are the following: (first row) an unidentified instructor, Earl Haring, Henry Greenawald, Howard DeLong, Stephen Schwartz, John Schreiner, Donald Kistler, Ralph Werley, and Harold Mohr; (second row) an unidentified instructor, Francis Laudenslager, unidentified, unidentified, John Schwartz, Harry Olanick, Harvey Schmick, and Mike Waricher; (third row) Dr. Guth, Carl Kocher, an unidentified instructor, Herman Klotz, LeRoy Moyer, Woodrow Neff, Harold Foose, Woodrow Lehr, Gilbert Holben, Stephen Perrine, Carl Ebert, George Pacuch, Raymond Moritz, and Thomas Kuhns. (Ray Zeigler.)

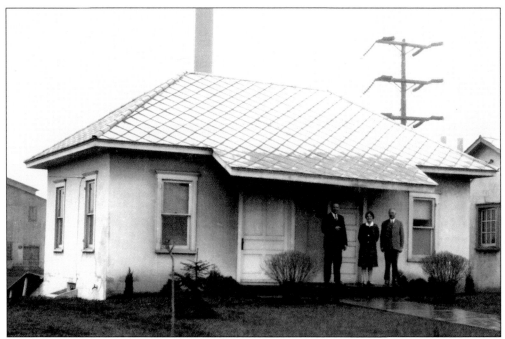

COMPANY HOSPITAL AND STAFF AND FIRST AID COMMITTEE. Dr. Guth (right) stands with the company nurse, whose first name was Ada (center), and an unidentified man on the porch of Lehigh Portland's hospital in Fogelsville on a rainy day in the 1920s. "One of the most important and essential facilities provided at all Lehigh Plants is a First Aid Hospital," wrote company president Joseph Young in 1955. "A doctor employed by the Company . . . is available at any time the need may arise." The wide door seen in the picture above, and the wide pavement visible in the foreground of the photograph below, allowed easy access to the building for a vehicle and stretcher carrying an injured worker. (Roy Lehr.)

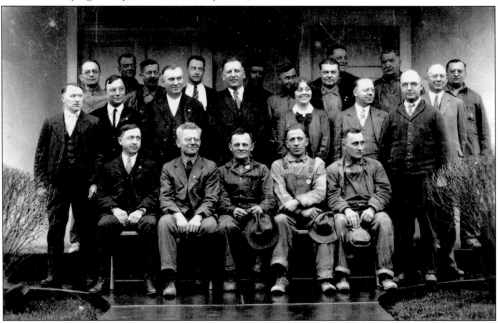

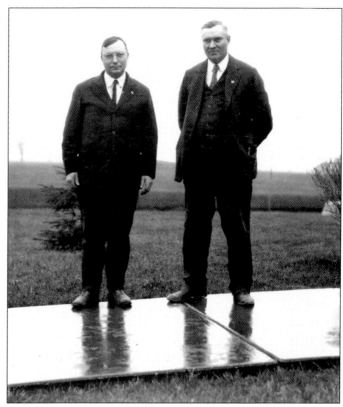

SAFETY TROPHY CELEBRATION, LEHIGH PORTLAND, FOGELSVILLE. Fred Haas (left) and Martin Lehr (right) accepted Lehigh Portland's first safety trophy from the Portland Cement Association and brought it to Fogelsville in 1928. They are shown in the picture to the right. Below is the podium for company officials ready for the dedication celebration for the trophy. The banner on the front reads, "Daddy Work Safely Keep Us Happy." (Roy Lehr.)

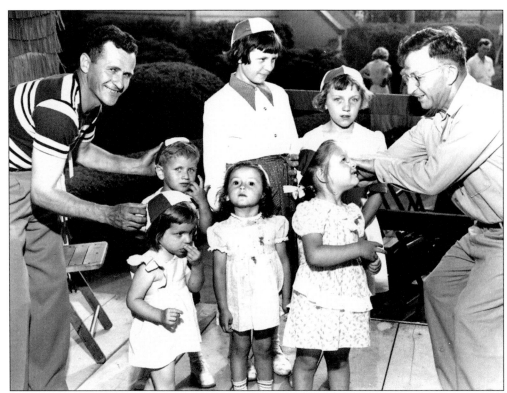

KEYSTONE CEMENT OPEN HOUSE. Children of Keystone workers get commemorative beanies (above) at a safety trophy celebration in front of the company headquarters in the 1950s. Below, family members tour the plant, stopping to learn about a lathe. (Edward Pany.)

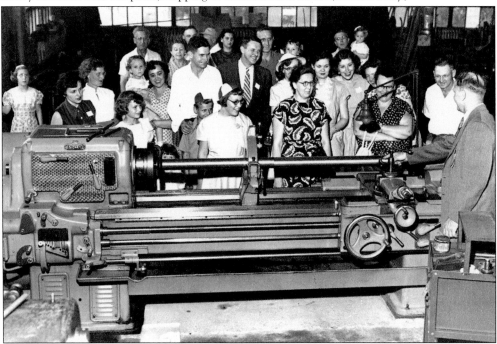

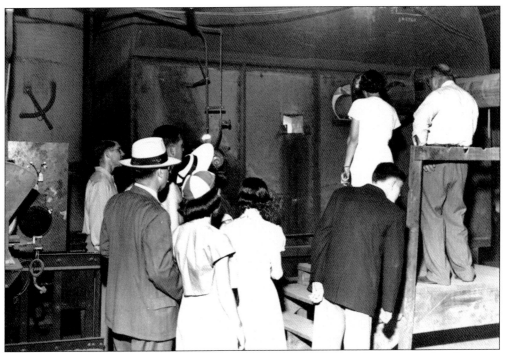

KEYSTONE CEMENT OPEN HOUSE. Visitors get a chance to peer inside a kiln on the plant tour (above) and later wash the dust away with a cool drink (below). (Edward Pany.)

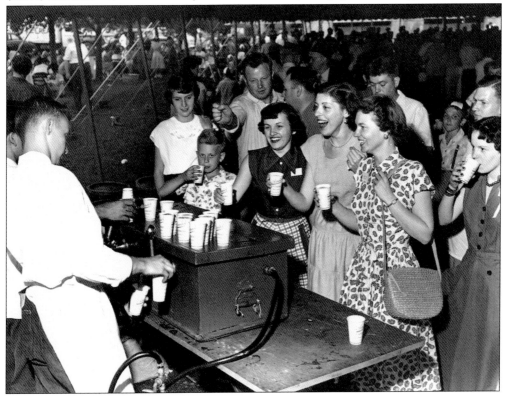

A Cement Worker and His Family. Frank Farkas came from Slovakia before World War I and worked at the Lawrence/Dragon/Martin Marietta cement plant in Northampton for 44 years. He and his family lived in one of the company houses, which were called "blockhouses" because they were built of cement block. In the photograph to the left, his daughters Helen (left) and Margaret (right) pose in the yard in 1932. The family dressed up for this formal portrait in the 1920s, but the Farkas girls wore their oldest clothes when doing their daily chores; sweeping up the cement dust on the sidewalk and front porch and scavenging coal along the train tracks that haul coal to the kilns. (Pris Koch and Helen Seikonic.)

CEMENT BAG COSTUME. This little girl looks a bit less than enchanted with her Halloween costume. Maybe her mother tried to convince her it was Cinderella's "before" costume. (Lehigh Cement Company.)

CHRISTMAS IN EAST FOGELSVILLE, C. 1930. Mothers and children are waiting for Santa in the company house neighborhood in East Fogelsville (left). By the 1930s, the houses pictured below had replaced the simple frame shelters seen on page 88. Santa's visit was an annual treat from the company for workers' children. (Left, Roy Lehr; below, Lehigh Cement Company.)

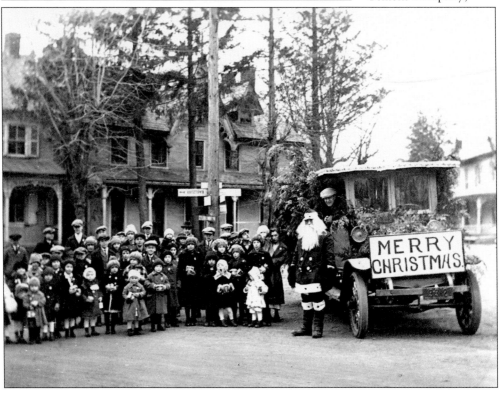

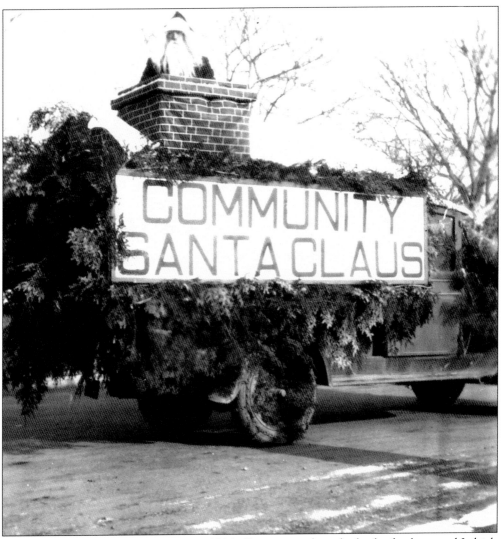

CHRISTMAS IN EAST FOGELSVILLE, C. 1930. Santa arrived on the back of a decorated Lehigh Portland truck. Then he descended and gave each child two presents—an orange and a box of candy. (Roy Lehr.)

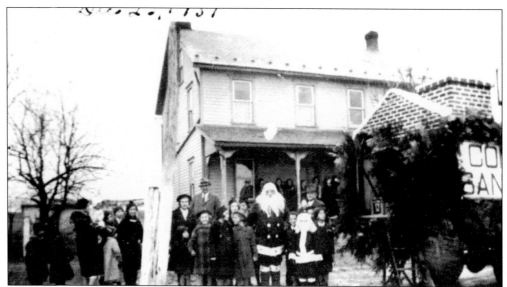

CHRISTMAS IN EAST FOGELSVILLE, C. 1931. Lehigh Portland's Santa (portrayed by the plant superintendent) and a small helper visit the Skrapits, Csensits, and Temmel families. His "sleigh" is on the right. After stopping in East Fogelsville, Santa moved on to the company houses in North Fogelsville and Ormrod. (Frank and Ethel Yandrisivits.)

CHRISTMAS, EDISON PORTLAND CEMENT, 1928. Santa graces a poster painted by C. W. Keeney for Edison Portland's Christmas decorations. (Ron Wynkoop Sr.)

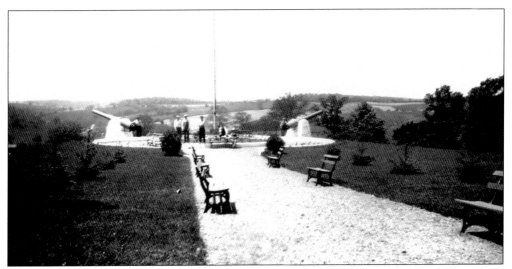

COMMUNITY PARK, NORTH FOGELSVILLE. Lehigh Portland set aside land on the hill north of the plant as a park for its workers. Along with open spaces, picnic pavilions, and benches, it boasted this war memorial. The park, now gone, was located just north of the present Hilltop Road. (Roy Lehr.)

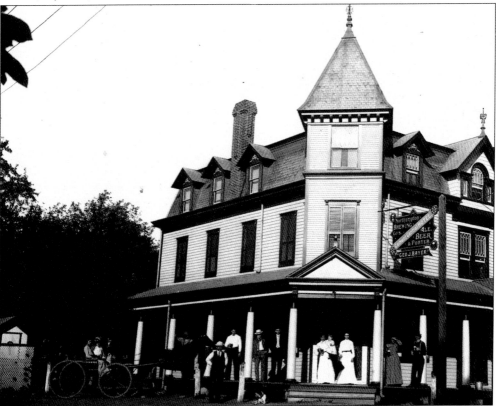

THE CEMENT CENTRAL HOTEL, NORTHAMPTON, C. 1905. The Northampton Brewery built its hotel at 1639 Newport Avenue, convenient for homeward-bound Lawrence cement workers to stop in and wash away some of the cement dust with a few beers. (Dick Schwechten.)

PENNSYLVANIA CEMENT COMPANY BASEBALL TEAM, EARLY 1920S. The victorious Pennsylvania 10 and their managers are, from left to right, Morris Fortuin, Harry Guth, Bob Mertz, Ralph Scheirer, Otto Kolbe, Paul Douglas, Judson Giles, W. P. Gano, Ed Guth, Floyd Gross, John Acker, and John Werkheiser. (Bath Museum.)

THE GIANT PORTLAND CEMENT COMPANY TEAM. The members of the Giant Portland Cement Company baseball team pose in 1955. (Richard Comp.)

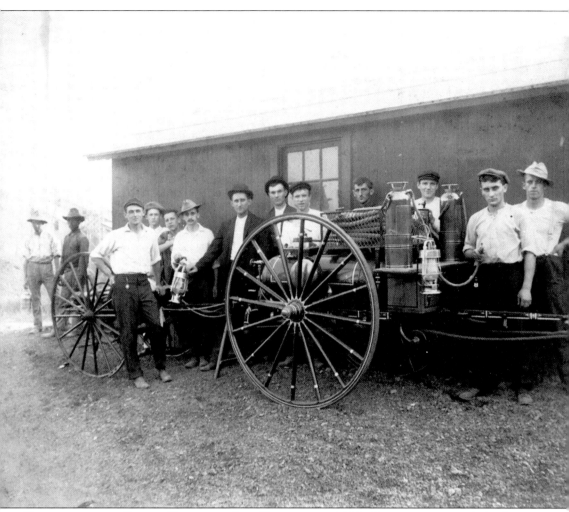

FOGELSVILLE AND LEHIGH PORTLAND FIRE COMPANY, C. 1900. Cement companies helped to fund fire departments in the communities nearby. This ensured fire protection for the company as well as the town. Lehigh Portland workers who were also Fogelsville's volunteer firefighters pose with their fire apparatus around 1900. (Roy Lehr.)

LEHIGH PORTLAND CEMENT PARADE FLOAT, SANDT'S EDDY, 1930S. This elaborate float, created for an unknown event, strikes a patriotic appearance while the signs on the side criticize imported cement. (Hunter-Martin Settlement Museum.)

KEYSTONE PORTLAND CEMENT PARADE FLOAT, 1950s. Female office workers grace a Keystone float in a parade that may have been in Bath. The round symbol in the middle reads, "Safety Always." (Bath Museum.)

PENN-DIXIE PORTLAND CEMENT PARADE FLOAT, 1940. Penn-Dixie has graced its dream house float with a white picket fence, a curved arbor, and Venetian blinds on its float for Nazareth's 200th anniversary parade in 1940. (Kathleen Unger.)

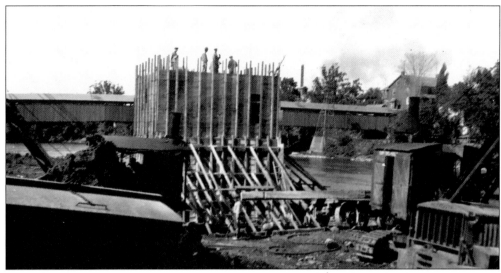

DAM AND PUMPING STATION, WHITEHALL CEMENT. Whitehall Portland built a pumping station (above) on the west bank of the Lehigh to provide water for the plant. To ensure an adequate, constant level of water for the pumps, the company also constructed a stone and timber dam just downstream of the bridge between Cementon and Northampton. The photograph below shows workers using a quarry engine and skip car to dump stone during the early stages of dam construction. (Above, Dick Schwechten; below, Lafarge.)

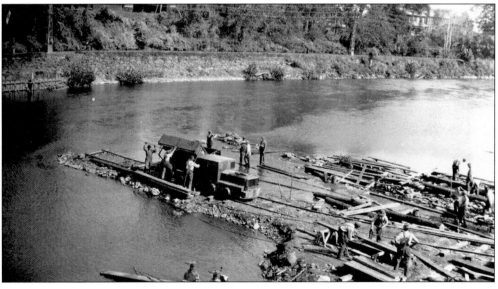

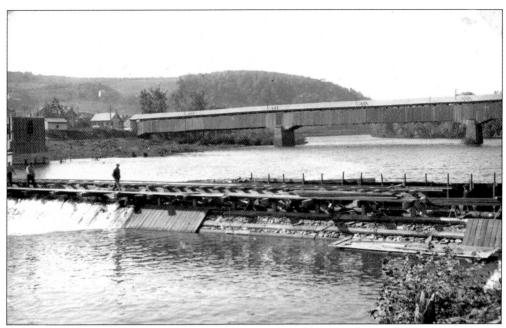

DAM AND PUMPING STATION, WHITEHALL CEMENT. By the time the picture above was taken, the dam, although still uncompleted, reached both banks of the Lehigh and was partially holding back the river. In 1956, the company replaced the original dam with a concrete one (below), which still stands. (Dick Schwechten.)

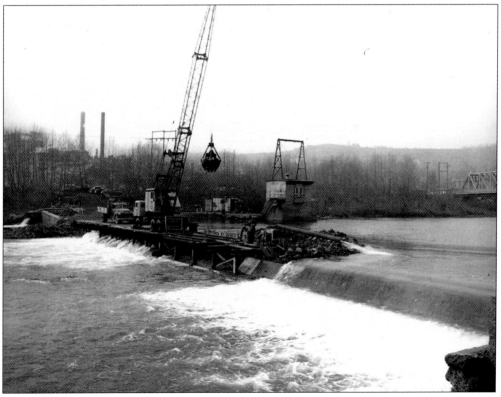

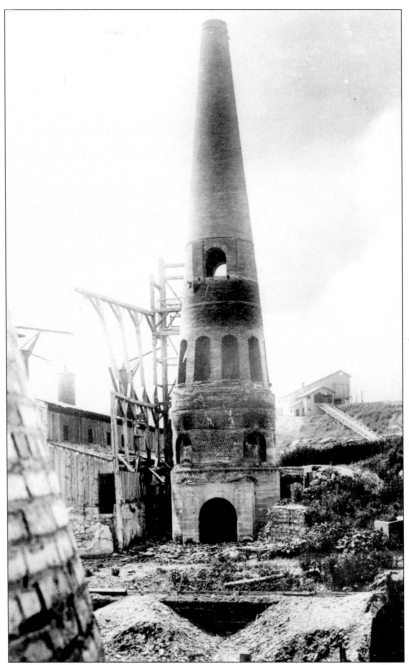

KILN DEMOLITION, COPLAY A MILL, 1922. Schoefer kilns like this one were obsolete almost as soon as they were installed, but some remained in use until the early years of the 20th century. Schoefer kilns were widely used in Europe, where labor was cheap and raw materials expensive. The opposite was true in the United States, but some American portland cement manufacturers believed that using the same process their European competitors did would convince American engineers and construction managers that their product was as good as the imported portland cement that was still widely used in the United States as late as 1890. However, the efficient, high-output rotary kiln soon supplanted vertical kilns everywhere. (Lehigh County Historical Society.)

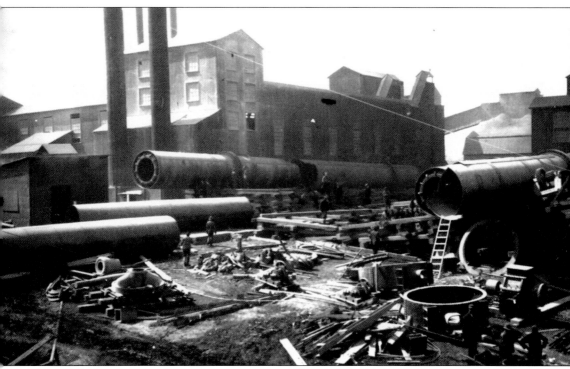

KILN CONSTRUCTION, WHITEHALL CEMENT, 1920S. This kiln-construction project at Whitehall Portland, going on at about the same time as the demolition on the opposite page, shows how far and how fast cement technology had progressed in less than 30 years. Whitehall's new kilns were over 300 feet long and capable of turning out more clinker in a day than an upright kiln could produce in a week or more. (Dick Schwechten.)

No.	Company Name	Town	Start - End	Successor	Present Owner
PORTLAND CEMENT PLANTS IN THE LEHIGH VALLEY					10/1/2004
					by Dave Drinkhouse
1	Allen	Northampton	1865-1891	Bonneville	
2	Allentown	Evansville	1910-present		Lehigh Cem. (German)
3	Alpha #1	Alpha, NJ	1895 - 1912		
4	Alpha #2	"	1901 - 1915		
5	Alpha #3	Martins Creek	1902 - 1929		
6	Alpha #4	"	1908 - 1964		
7	American "Egypt"	Egypt	1883 -		
8	American "Penna."	"	1891 -		
9	American "Columbian"	"	1892 -		
10	American "Giant"	"	1895 -		
11	American "Central"	"	1903 -	Giant	
12	American "Reliance"	"	1905 - 1912	"	
13	Atlantic	Stockertown	1908 - 1916	Hercules	
14	Atlas #1 "Valley Mill"	Coplay	1889 - 1903		
15	Atlas #2	Northampton	1896 - 1930	Universal Atlas	
16	Atlas #3	"	1900 - 1930	"	
17	Atlas #4	"	1905 - 1944	"	
18	Bath	Bath	1905 - 1925	Lehigh	
19	Bonneville	Northampton	1890 - 1899	Lawrence	
20	Bonneville	Alpha, NJ	1891 - 1893	Whitaker	
21	Coplay - "A"	Coplay	1874 - 1906		
22	Coplay - "B"	"	1893 - 1904		
23	Coplay - "C"	West Coplay	1899 - 1978		
24	Dexter	Nazareth	1901 - 1926	Penn-Dixie #4	
25	Dragon	Northampton	1951 - 1961	Martin-Marietta	
26	Edison	New Village	1902 - 1942		
27	Essroc I	Nazareth	1978 - present		Italcementi Group
28	Essroc III	"	1995 - present		Italcementi Group
29	Giant	Egypt	1912 - 1975	Coplay/Essroc	
30	Hercules	Coplay	1888 - 1901		
31	Hercules	Stockertown	1916 - present		Buzzi Unicem SpA of Italy
32	Keystone	Coplay	1889 - 1891	Atlas #1	
33	Keystone	Bath	1928 - present		Cementos (Spanish)
34	Lawrence	Northampton	1899 - 1951	Dragon	
35	Krause	Martins Creek	1900 - 1901	Martins Creek	
36	Lehigh	Bath	1925 - 1930		
37	Lehigh mill "H"	Fogelsville	1907 - 1970		
38	Lehigh mill "A"	Ormrod #1	1898 - 1927		
39	Lehigh mill "D"	" #2	1902 - 1958		
40	Lehigh mill "F"	" #3	1903 - 1936		
41	Lehigh mill "R"	Sandts Eddy	1926 - 1960		
42	Lehigh mill "B"	West Coplay	1901 - 1928		
43	Lone Star	Nazareth	1925 - 1994	Essroc III	
44	Martins Creek	Martins Creek	1901 - 1908	Alpha #3	
45	Martin-Marietta	Northampton	1961 - 1983		
46	Nazareth	Nazareth	1899 - 1966	Coplay/Essroc	
47	National	Martins Creek	1904 - 1908	Alpha #4	
48	National	Brodhead	1935 - 1974		
49	Northampton	Stockertown	1901 - 1909		
50	Penn-Allen	Upper Naz Tp	1904 - 1926	Penn-Dixie #5	
51	Pennsylvania	Bath	1903 - 1926	Penn-Dixie #6	
52	Penn-Dixie #4	Narareth	1926 - 1979	Coplay/Essroc	
53	Penn-Dixie #5	Upper Naz Tp	1926 - 1966		
54	Penn-Dixie #6	Bath	1926 - 1963		
55	Phoenix	Narareth	1902 - 1928	Lone Star	
56	Universal Atlas	Northampton	1943 - 1982	Lehigh	
57	Vulcanite #1	Alpha, NJ	1895 -		
58	Vulcanite #2	"	1900 - 1928		
59	Vulcanite #3	"	1901 - 1932		
60	Whitaker	Alpha, NJ	1893 - 1895	Alpha #1	
61	Whitehall	Cementon	1899 - present	General/Lafarge	Lafarge Corporation
	a:\PCplants.XLS		clinker production		

CEMENT CHRONOLOGY, 1865–PRESENT. This chart was compiled by former Alpha Portland engineer and plant designer David Drinkhouse. It shows the original names, later names, dates of operation and shut down, location, and current owner, of every cement mill in the Lehigh District.

Seven

CEMENT TODAY

There are five companies producing cement in the Lehigh District, each one operating quarries and mills at sites that have been in use for at least 80 years. Currently, the industry is robustly healthy, and there is an unprecedented demand for cement all over the world. All five plants in the Lehigh Valley are pictured on the following pages in photographs supplied by the companies. All of them are running at full capacity and are part of large international corporations that serve global customers.

LEHIGH CEMENT, EVANSVILLE, PENNSYLVANIA. Lehigh Cement Company employs about 6,000 people and operates 12 cement plants in North America; its Evansville plant, near Fleetwood, is the company's only remaining production facility in the Lehigh District. This plant has been in operation since 1910, when it began as the Allentown Cement Company. Lehigh's corporate headquarters also remain in the Lehigh Valley, in Fogelsville near the site of the former Mill H. Lehigh was acquired in 1977 by a German firm, the Heidelberg Cement Group, which is now one of the world's leading producers of cement and construction materials. The company name was changed from Lehigh Portland Cement in 2002.

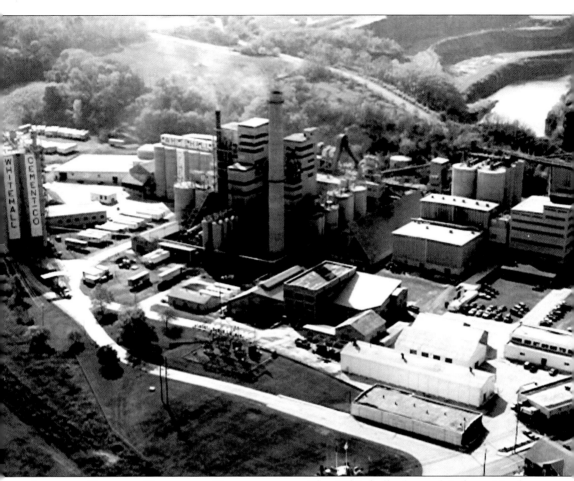

LAFARGE CEMENT, CEMENTON, PENNSYLVANIA. The Whitehall plant of Lafarge North America employs over 100 people and produces 10 different types of cement. The former Whitehall Portland facility, opened in 1899, was acquired by Lafarge, a Canadian company that is the largest diversified supplier of construction materials in North America, in 1982. The plant, which derives 40 percent of the fuel for its kilns by burning discarded tires, produces 800,000 tons of cement a year.

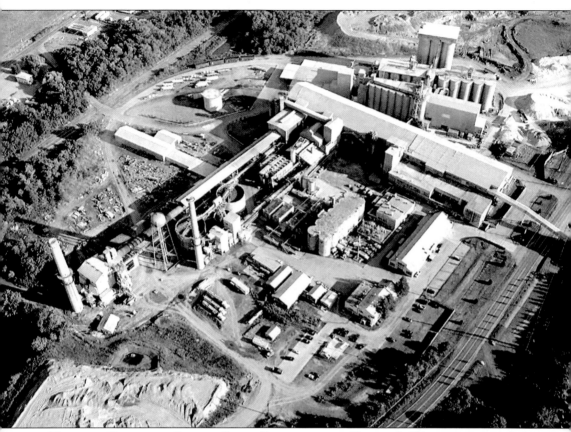

KEYSTONE PORTLAND CEMENT, BATH, PENNSYLVANIA. Keystone's 850-acre quarry and plant are located in Bath and East Allen Township. Keystone has 185 employees and is a subsidiary of Giant Cement Holding, which in turn is a subsidiary of Cementos Portland, S.A., based in Madrid. Keystone manufactures portland and masonry cement in two kilns; one, at 540 feet long, is the second largest kiln currently operating in the United States. The company produces 650,000 tons of cement per year, using some types of industrial waste as part of its energy source.

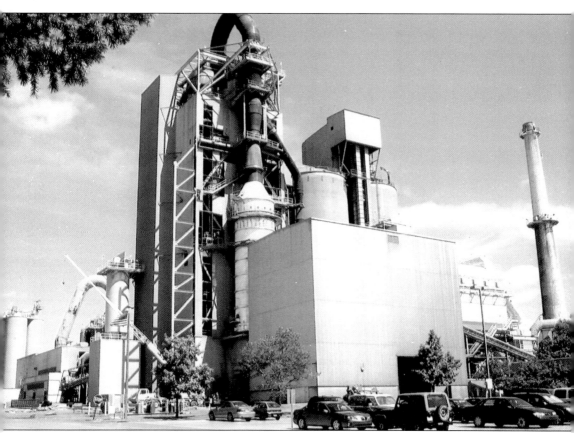

Essroc Cement, Nazareth, Pennsylvania. A subsidiary of Italcementi, the Essroc plants in and near Nazareth are the former Lone Star, Nazareth, and Penn-Dixie No. 4 plants. In 2005, the company completed a major upgrade of its facilities, including a $15 million, 1.7-mile-long underground conveyer, which carries stone from the quarry west of Nazareth to the company's plant east of town.

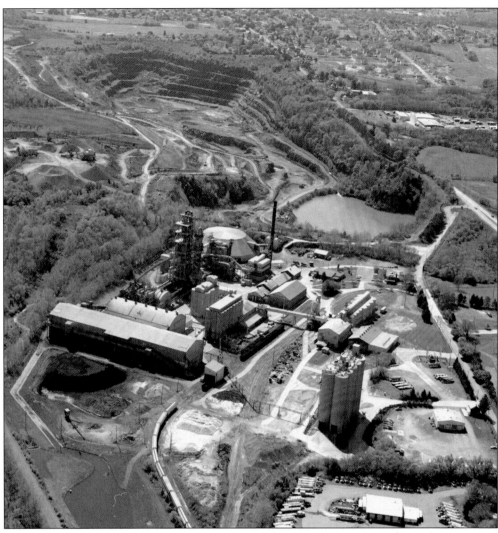

HERCULES PORTLAND CEMENT, STOCKERTOWN, PENNSYLVANIA. A part of Buzzi Unicem SpA of Italy, Hercules produces an average of one million tons of cement per year. In 1996, the company undertook a $42 million modernization that included construction of a domed raw material blending building that holds 35,000 tons of stone and is 269 feet in diameter and a kiln 12 feet in diameter and 200 feet long. The plant's 260-foot-tall pre-heater tower has become a landmark, especially when it is lighted at night.